Secrets of
WATERCOLOR
FROM BASICS TO SPECIAL EFFECTS

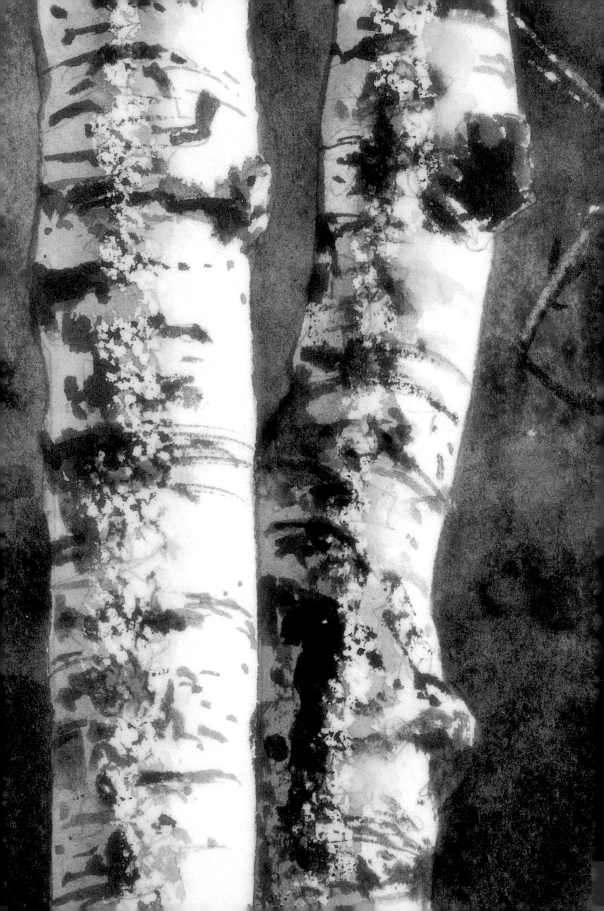

"ESSENTIAL ARTIST TECHNIQUES"
"Secrets of"
"WATERCOLOR"
"FROM BASICS TO SPECIAL EFFECTS"
"Joe Garcia"
"NORTH LIGHT BOOKS / CINCINNATI, OHIO / www.artistsnetwork.com"⁕{ ESSENTIAL ARTIST TECHNIQUES }⁕

Secrets of
WATERCOLOR

FROM BASICS TO SPECIAL EFFECTS

Joe Garcia

NORTH LIGHT BOOKS
CINCINNATI, OHIO
www.artistsnetwork.com

CONTENTS

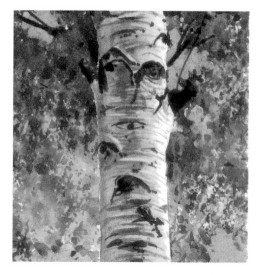

CHAPTER TWO

60 PAINTING POPULAR SUBJECTS

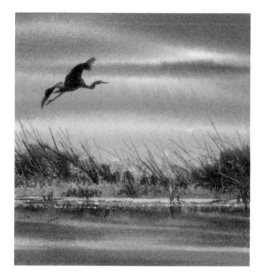

First Dip
Watercolor on 300-lb. (640gsm) cold-pressed paper
24" x 32" (61cm x 81cm)

GETTING STARTED

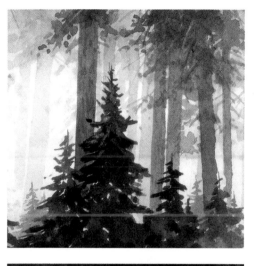

Watercolor Paints

Watercolors come in tubes, cakes or pans, pencils or liquids. They vary in price and quality, and there are many brands available. Stick to the professional quality paints, which offer consistency of color, lightfastness and a general degree of excellence.

Transparent paints (as opposed to opaque paints such as gouache) consist of pigment mixed with gum arabic, glycerin and a wetting agent. When you thin the paint with water, the glycerin and water allow the pigment to adhere to the surface of the paper. The wetting agent allows the paint to flow evenly as it is diluted.

Pan or cake paints come in half and full pans, individually or in kits. Kits are compact, travel well, and are useful for doing small paintings; however, it is difficult to mix enough paint for large, even washes. Cakes are small and you will use your favorite colors quickly, so have extras available.

Know Your Hues

Paint names followed by Hue (Hooker's Green Hue) tend to be of a lower quality. They are made with an imitation product of the actual pigment.

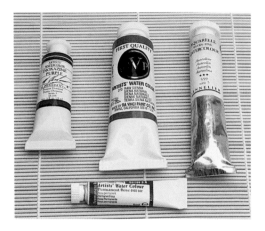

Tube Paints
These are sold as small (5ml), medium (14–16 ml) and, occasionally, in large (37ml) sizes.

Small Traveling Palette

Palette

Palettes come in a variety of shapes and sizes. A white dish, butcher's tray or cookie sheet will suffice, but a traditional covered palette is best. A good palette has large separate wells or reservoirs to store each color and a large mixing area with no divisions. The deep wells are important because they allow you to have a lot of pigment available. They also keep colors from being contaminated by adjacent colors and help you see and arrange your colors in a logical order. The open mixing area allows you to mix enough color to get rich, saturated washes.

MIXING COLORS ON A PALETTE

Make sure to always mix enough paint to avoid running out in the middle of your painting. A palette that has a large flat area is helpful for this.

INCOMPLETE MIXING

Pull two or three colors from the palette wells and allow them to partly mix on the palette. Drag your brush through these colors and

Pick Your Palette

A palette influences how you paint. A good palette is one that starts you on a logical journey through your painting.

Divided mixing areas restrict mixing large pools of paint.

Large paint wells fit large brushes and are good for mixing large washes.

Flat well construction helps keep dirty color away from the pigment in the well.

Slated or round wells allow contaminated color to flow up to and around the pigment already there.

apply to your paper. The parent colors retain some of their identity while also mixing on the paper surface. Some of the parent colors remain visible, resulting in washes that are interesting and spontaneous.

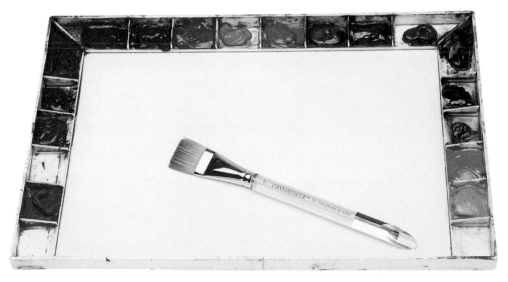

Placing Colors
Pictured is my prefered palette, the John Pike palette. My warm colors are on the left, blues and greens across the top and my earth tones and yellows are on the right. I do not fill all the wells, but use the open wells for an occasional new color. Once you have decided on the arrangement of your pigments, keep it that way for every palette you make up.

Brushes

The success of what or how you paint depends on the brushes you use. Use what you can afford and works for you. My brushes consist of a couple of kolinsky sables (1-inch [25mm] flat, no. 10 round) and a variety of synthetic brushes. Sizes range from a no. 10 round to a no. 2 round. The flats are ½-inch (12mm), 1-inch (25mm) and 2-inch (51mm) synthetics. I generally return to the same old favorites.

Pick brushes for the job they do. Flat brushes hold a lot of paint or water and are the workhorse for wet-into-wet washes. Use large flats for wet-into-wet washes or small flats for fine detail work. They are good for creating texture or, if a bit worn and blunted, to lift out areas. Rounds hold a lot of fluid because of their shape.

Each area of your painting will require a specific brush. Always start with the largest brush possible. Switch to smaller brushes for detail as the painting progresses. Your painting style and technique will develop and be enhanced according to how you use your brushes.

SYNTHETIC BRUSHES

Synthetic brushes are affordable and less intimidating than natural fiber brushes. They wear out faster, but the low cost helps make up for that. I like the springy, resilient quality of a good synthetic brush and use them almost exclusively. I tend to be a rough painter and do not mind buying brushes a little more often.

Flat and Round Brushes

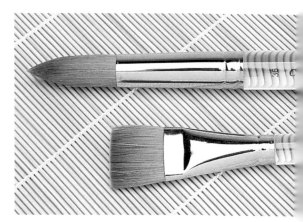

Brush Quality
Brushes should have good shape and construction—no shedding or bent hairs. If the handle is wood, it should be lacquered. The ferrule should be seamless.

NATURAL BRUSHES

Natural fiber brushes are made of anything from kolinsky sable to goat hair. Sable brushes retain water best and have a springy point. The natural fiber brushes are expensive but have long life, great water retention and spring.

Brush Care

- Do not leave brushes tip down in a water container. This breaks the ends of the fibers and also bends and twists them out of shape.

- Wash your brush with mild bar or liquid soap to remove paint that would dry and break hair or fibers of the brush. Doing so also keeps unwanted pigment from building up in the belly of the brush.

- Form your rounds to a point and your flats to a square before you store them to dry.

- To enhance the longevity of your brushes, use an old round for mixing paint on your palette.

Transporting Brushes

Proper transportation of your brushes is important. Do not just lay them in your box or carrier. The brushes will bounce around and the tips and edges will get damaged. Use a brush holder that separates brushes individually. Place them separately on a bamboo place mat as you roll it up. Use a strong rubber band to keep it rolled.

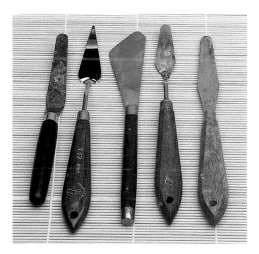

Palette Knives

With a little practice, the palette knife can be an important addition to your painting kit. Look for one that is flexible and easy to hold so you can apply pressure in varying degrees. Use it like a squeegee to remove paint or like a knife-edge to draw a fine line or apply paint. Practice makes perfect, but remember: This is one tool that will damage the surface of the paper, so be careful.

Paper

Paper comes in blocks, sheets or pads; numerous brands of high quality papers are available. Try many brands of paper to find one you like.

Paper comes in three textures: hot-pressed (very smooth), cold-pressed (lightly textured) and rough (heavily textured). Cold-pressed paper is a good surface with which to start.

Paper comes in various weights. The weight or thickness is based on a ream, or five hundred sheets of paper. A standard sheet of watercolor paper is 22" × 30" (56cm × 76cm). As an example, five hundred sheets of cold-pressed paper weighs 140 lbs. (300gsm). I use 140- or 300-lb. (300gsm or 640gsm) Arches cold-pressed paper most often. The surface handles my rough way of painting.

OTHER SURFACES

Your surface affects the style or technique of your paintings. A soft paper may not work well if you like to scrub, lift, scratch or texture your paintings. Surfaces can vary from Yupo (a "plastic" paper) to illustration board. Select paper paper that is 100-percent cotton fiber, with the exception of Yupo. All high-quality papers are acid-free. Illustration board comes in various weights and surface textures.

Types of Paper

Paper sheets are handmade, mouldmade or machine-made.

- Handmade papers are expensive, but have a high degree of excellence.

- Mouldmade papers are durable and generally of good quality.

- Machine-made papers are the least desirable. Their defined surface texture looks mechanical and is often used in student-grade pads.

Hot-pressed

Cold-pressed

Rough

Handmade

Stretching Paper

Paper stretching is the process of soaking the paper, attaching it to a board, then letting it dry completely. The paper expands as it is soaked, and, as it dries, it shrinks to a nice, flat surface. This shrinkage helps keep the paper from buckling as you paint. Use paper tape or staples to adhere the wet paper to the board. Tape works best for lightweight paper up to 140 lbs. (300gsm). You will have better success with staples on the heavier papers. Placing the staples close together keeps the paper from pulling up from the board. A heavy, stiff board that will not bend or warp is essential.

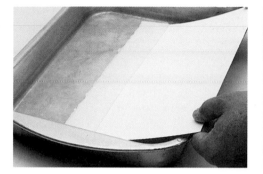

1. Soak the Paper Thoroughly
Soak 7–10 minutes for 140-lb. (300gsm) paper, 30–45 minutes for 300-lb. (640gsm) paper.

Substitute Tape for Staples

If you don't want to mount your stretched paper with staples, precut four lengths of gummed paper tape.

1. Lightly dry the edge of the paper with paper towels.

2. Moisten the tape. (Be careful not to overmoisten the tape, as it will be less likely to adhere to the paper.)

3. Overlap your paper with the damp tape by about ½" (12mm).

4. Burnish down the edges of the tape.

5. Allow the paper to dry completely. The paper will shrink and leave a tight flat surface.

2. Drain and Place
Drain off excess water and place on mounting board. Use a sponge to flatten and wipe off excess water.

3. Secure the Paper
Stapling the paper is the easiest way to mount the paper. A heavy-duty electric stapler is helpful. Place staples approximately ½" (12mm) from the edge of the paper. Heavier paper requires more staples.

Other Supplies

Your tools and materials, such as pencils, paper and sponges, must be in easy reach to facilitate your painting.

ARTIST'S TABLE

An artist's table is like a mechanic's workbench. It is covered with tools.

PENCILS

Pencils come in a wide range of hardness, from 9B (very soft) to 9H (very hard). If you are sketching a drawing that you will paint, a soft pencil may smudge too easily. A hard lead pencil, on the other hand, will score or leave an indentation on the surface of the paper, showing up later in your painting as an unwanted dark line. I use a 2H or 3H pencil, which makes a line that's easy to see as I paint. I like to use softer pencils to draw in a sketchbook. They give variety to the linework.

SPONGES

Sponges offer a great opportunity to play with texture. A natural sponge is great for creating trees or rocks. Load it with paint and gently press it to the surface of the paper. Use a variety of sponges, each with a different texture. A synthetic sponge is good for applying washes or picking up paint, but its uniform surface lacks interesting textures.

MASKING FLUID

Masking fluid creates a water-resistant barrier between the paint and the paper. It is a liquid that is applied to the paper with a brush, stick, sponge, etc. It is similar to rubber cement but is made specifically for watercolors. If you use a brush, load it with liquid soap before dipping it into the masking fluid so it won't penetrate the belly of the brush. Don't allow the masking agent to dry because it will ruin the brush.

GOUACHE

Gouache is technically an opaque watercolor, but you can thin it with water and make it transparent. You can use it on a number of different surfaces, such as primed canvas, illustration board or watercolor paper. A toned or colored paper is ideal to use because of the opacity of gouache.

CAMERA AND LENSES

The camera is an important tool that allows the artist to record ideas or references that might otherwise be lost. Cameras may be as simple as a "point and shoot" or as high-tech as a digital. The standard digital SLR is sufficient. Most have interchangeable lenses. A zoom lens can help you crop and compose a photo for a future painting.

GENERAL MATERIALS

Every artist has equipment or materials that will help him make his painting unique. Make sure these tools of the trade are readily available: drawing boards of various sizes, masking tape of various widths (some to create textures and some simply to tape down your paintings), a craft knife, paper towels and a water bucket. Sandpaper or emery cloth, paraffin and spray bottles all come in handy as well. The list continues. You need tools or equipment that enhances or complements your painting technique. Observe what other artists use. You may find another treasure to add to your box of tricks.

Odds and Ends
Materials helpful to have on hand while painting.

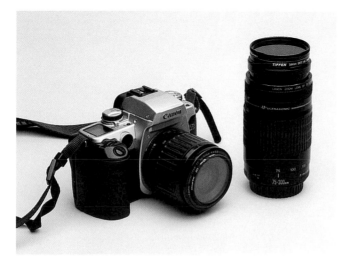

35mm Camera, 35–80mm and 75–300mm Zoom Lenses.

Go Digital

Digital cameras are affordable and offer many advantages over the 35mm. Some are small with high resolution and have interchangeable lenses. They allow you to see the image immediately. You can store and catalogue the picture in your computer or print it without the delay of processing.

Design Basics

A good composition keeps the viewer interested in the art by arranging all the parts of the image into a balanced, pleasing design. A poorly composed painting will cause the viewer to become bored or confused. Capture the imagination and attention of the viewer by using the elements of design.

RHYTHM

This is the repetition of elements such as shape, color, value, line and pattern. It helps unify the different areas of the painting. However, there must be variety in the repetition or the image will become static and boring.

BALANCE

Good balance allows the viewer's eye to travel easily across the image. Create balance by giving the different elements equal emphasis. The variety of shapes and values, if well organized, will support the center of interest. The center of interest will be difficult to find if the balance is not correct.

UNITY

Unity creates a visual relationship between the different elements in a painting. It brings all the elements together to form a cohesive balance. However, too much unity and similarity can result in an uninteresting design or composition. Then the eye will become bored and leave the painting—not the effect a good artist hopes to have. Ideally, the viewer focuses first on the center of interest and then naturally follows the composition through the painting.

HARMONY

Harmony is the pleasing arrangement of all the individual parts of a painting. These parts could be theme, unity of elements or the use of color. Of these choices, color is most commonly used to create harmony. Colors must work together to create harmony. Artists use color harmony to create mood or an emotion. Analogous colors or those that are closely related on the wheel are especially good for this purpose. Snow scenes often use harmonious blues, and sunsets consist of reds and oranges. Limiting color increases the likelihood of color harmony.

EYE FLOW

Eye flow and composition depend on each other. If compositional elements fall short, eye flow is lost. The eye generally moves from left to right and top to bottom. The initial sketch or drawing provides a foundation to develop this movement, using elements such as mass, line, color and value. Visual pathways are formed and will lead the viewer in the desired direction. A road, path or river moving into the picture plane is the classic example.

SYMMETRY VS. ASYMMETRY

To have a successful painting, symmetry and asymmetry must work together. A good composition or design will use both concepts. If your painting is too symmetrical, it will be stiff and boring and will lose its visual excitement. Asymmetry refers to an imbalance of parts. It creates a tension that uses the imbalance to move the viewer through the painting. Used together, symmetry and asymmetry create a flow and rhythm throughout the painting.

Balance: The left and right side of the painting are balanced by value and the weight of the trees and foliage.

Rhythm: The constant change of value and size of the trees carried across the painting creates rhythm in the composition.

Unity: The overall use of color, value and eye flow unifies the painting.

Harmony: Limited use of color creates harmony.

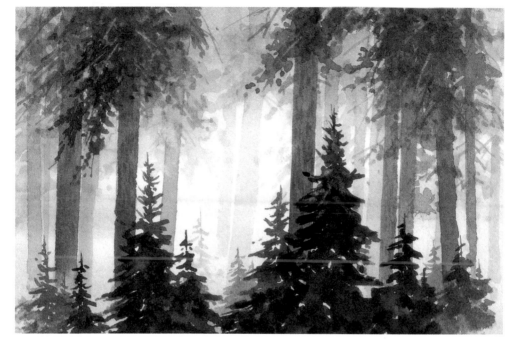

Symmetry vs. Asymmetry: Asymmetry is created by the change of scale, value and placement of the trees.

Eye Flow: Eye flow is encouraged by the size and value of the foreground trees. The eye travels from left to right, moving up to the large trees. The dark foliage of the large trees travels across the painting, then downward. This could be considered an O composition, with elements of the steelyard composition included.

Forest Glow
Watercolor on 140-lb. (300gsm) cold-pressed paper
5" × 7½" (13cm × 19cm)

Value

Value is the term used for the relative lightness or darkness of an area. This range of value stretches from white to black. Within the range there is an infinite number of values, and, to be successful, you should use a manageable number. Between five and ten steps in value is a good range to use. Color also has value. Lemon yellow is light in value, while French Ultramarine is dark in value. Therefore, the local color of the subject should be taken into consideration when painting. This could influence the composition of the painting. If you are working from a photograph and are not sure of the values, have a black and white copy made. In black-and-white, you will see the tonal values of the subject and not the color. This will help you compose, simplify and change values in your painting.

I like to use a gradated wash to create a value scale. It reflects how and what I like to paint. It is also easier to do! A value scale should go from the richest saturation of color to white, with a graduated transition from beginning to the end. Remember all colors have a full saturation value.

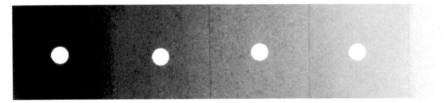

Create a Value Scale

Commercially made value scales can be purchased at most art stores, but making your own scale is a good and valuable lesson. First, draw a 7½" × 1½"(19cm × 4cm) rectangle on your watercolor paper. Now create five 1½" (4cm) squares within this rectangle. Lay masking tape around the border of the rectangle and burnish it down. Start the gradated wash with a full saturation of Lamp Black, using a 1-inch (25mm) flat brush. Now dilute this color by adding water to your brush. Do not rinse; only add water. With horizontal strokes, pull the color down. Keep diluting the color in your brush to the last square. The last square should be white. If you used a lot of water, pick up the paper and tilt it back and forth to help smooth out any brushstrokes. Doing this and leaving the last square white will take practice. When the wash is dry, gently pull the tape away from the image. Redraw the 1½" (4cm) squares and, with a hole punch, put a hole in the center of each square. Put the scale up to your painting and look through the holes to see the color and value of your subject.

Focal Point

The center of interest, or focal point—the dominant subject in the painting—is the place where you want to direct the viewer's attention. It is important that only one point dominates the composition so as not to confuse the viewer. Situate the focal point on any visual plane in the composition: the foreground, middle ground or background. When the focal point is in the background or middle ground, the artist asks the viewer to move into the picture plane. In a portrait, the center of interest (the person) is in the foreground and the eyes quite often become the focal point. Make the areas that surround the focal point less important by using weaker values and less detail, patterns or color. You can also use these elements in combination.

ARTISTIC LICENSE

Deciding on a focal point or center of interest often requires the use of artistic license. In a landscape you may need to move, eliminate or exaggerate what really exists. In a still life you may need to subdue the shapes, color and values to emphasize or establish the center of interest.

RULE OF THIRDS

Using the rule of thirds is a good way of establishing a focal point. You do this by dividing the picture plane into thirds with vertical and horizontal lines. These divisions establish four points of interest. This in conjunction with other elements of composition will direct the viewer to one of these points.

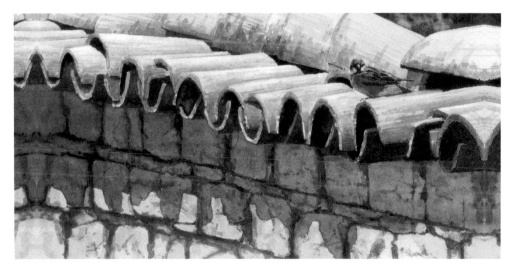

Break Up Repetition
In this painting the bird is the focal point. It changes the repetition of shapes. I used this rule to place the bird in the focal point. It is often better to eyeball or guess at the focal point than be mathematically correct.

Spanish Tile
Watercolor on 140-lb. (300gsm)
cold-pressed paper
5" × 9" (13cm × 23cm)

Contrast

Contrast is the distance of a value range. The contrast can be from white to black or anywhere in between. Strong contrast is important because it allows you to see how the image is formed. The higher the contrast, the more basic the shape becomes. Learn to see the value patterns that describe shape. A strong light source creates a distinctive subject with strong shadow patterns. A soft light source is less dramatic, with diffused shadows, and creates a moodier effect. Contrast helps the viewer differentiate between the subjects and the background and directs the viewer's eye to the center of interest, because it is the point of highest contrast. To see a light area, surround it with dark value. To see a dark area, surround it with light value. This is the fundamental concept behind painting negative and positive shapes.

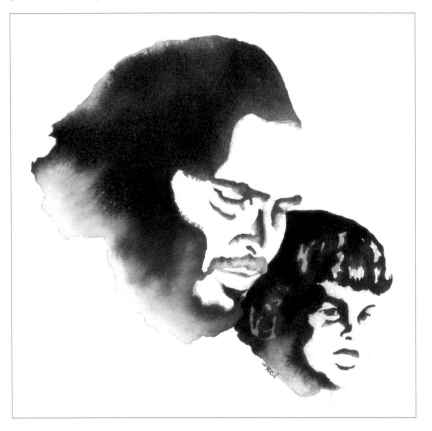

Strong Contrast Describes Shapes
I used contrast to eliminate unnecessary detail while painting the two faces. I created negative and positive shapes to describe the features of each person.

The Boys
Watercolor on 300-lb. (640gsm) rough watercolor paper
6" × 6" (15cm × 15cm)

Negative Space

A painting is composed of negative and positive shapes. Thoroughly understanding the positive shapes determines how well you understand the negative space. Negative shapes are created by the space around and between the positive shapes. You can recognize negative space more easily when positive shapes are strong and visible. Use negative shapes to support, describe and define form. Think of them as the opposite of a silhouette. In this case, the background is a dark value. The contrast makes the positive shapes stand out. Use negative space to move the viewer's eye around the picture plane. In a composition, you want to create a pleasing balance between the negative and positive shapes. This balance creates eye flow with a sense of harmony and rhythm, and ultimately gives the composition unity.

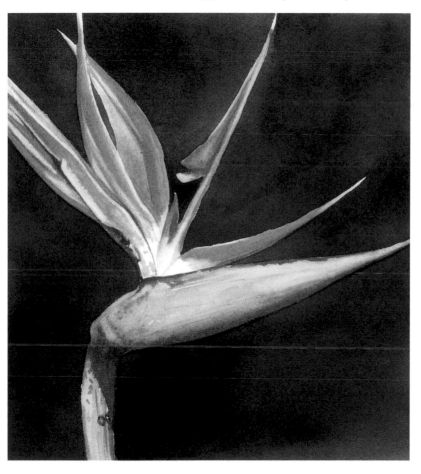

Qualities of Negative Space
Negative space should have interesting shapes and support the center of interest.

Bird of Paradise
Watercolor on 140-lb. (300gsm) cold-pressed paper
6" × 5½" (15cm × 14cm)

Editing for Strong Composition

It is often difficult to analyze the composition in a subject. There can be too much information, which makes the composition visually confusing. You can develop a strong, dynamic composition by editing your image. Thumbnail sketches help in editing because they eliminate unnecessary detail and capture the essence of the subject. Use thumbnails as a starting point in developing a vertical or horizontal format. After making a thumbnail, create a comprehensive, detailed sketch to develop the value and line elements of the design. Edit and develop the composition as you work toward the painting process.

You can also use a commercial viewfinder to isolate and edit unwanted information. If you don't want to buy one, use an empty slide holder or an old mat.

Practice developing your personal expression, or artistic license. Subjects seldom come ready to paint, especially when you're painting a landscape. (Mother Nature supplies too much information.) You must eliminate unnecessary elements. In a still life, you can move or adjust objects to strengthen the composition. You can also change or edit textures and values to accent the focal point.

Use a Viewfinder

A commercial viewfinder looks like a square mat with one adjustable side. By sliding the adjustable edge in and out you can create your own format. The viewfinder should be large enough to easily hold and look through. A good viewfinder will also have standard frame sizes marked along the edge. This helps give you reference sizes to paint by. Crop into the image by extending your arm and looking through the viewfinder.

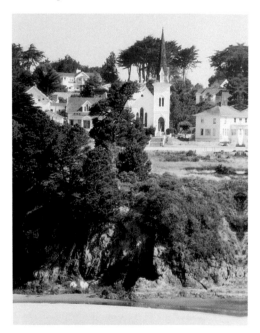

The Tower, Reference Photo

Crowquill Pens

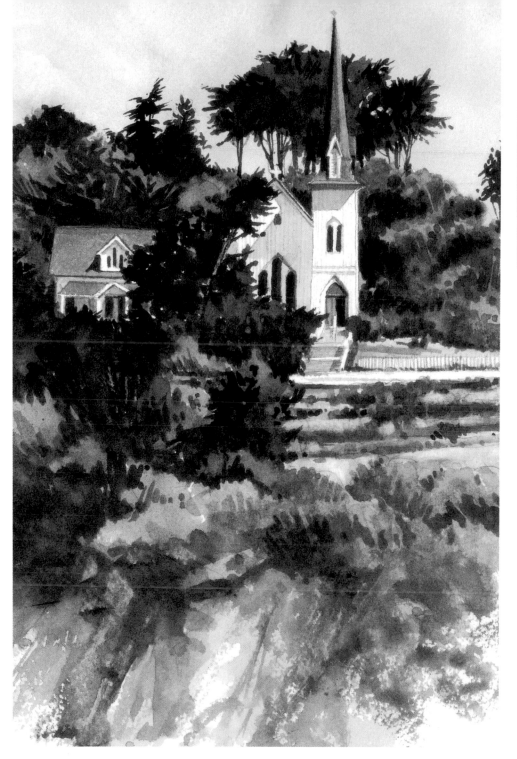

Edit Features You Don't Want to Use

With this painting I took out unwanted buildings and simplified areas of foliage, especially near the church tower. I also simplified the cliff and vignette areas in the lower right side of the photograph. By doing this I was able to create a path for the viewers eye to move from the bottom of the painting upwards toward the building.

The Tower (Mendocino, California)
Watercolor on 140-lb. (300gsm)
cold-pressed paper
8½" × 5½" (22cm × 14cm)

Transferring an Image

TRANSFER PAPER

The best and easiest way to transfer a drawing or sketch to watercolor paper is to use a graphite transfer sheet. This is a commercially made paper that has a thin coating of graphite on its underside. When you draw on the top side of the paper, a line is transferred to the surface on which it has been placed. Some transfer papers have an oily residue that resists watercolor.

PROJECTORS

Projectors, such as opaque, overhead or slide, make it easy to transfer drawings and adjust their size. However, it can sometimes causes you to follow the reference too closely. Don't be afraid to change or alter what is projected.

GRID SYSTEM

To use the grid system, first create reference points on a grid over the drawing or reference to be enlarged or reduced. Then simply follow the points. This is an easy system to use, especially when you're working with several drawings or pieces of reference. Do the initial drawing on tracing paper. Lay additional sheets over the first drawing to easily see and adjust the original drawing. Continue to refine the drawing in this way until it is satisfactory. Then transfer the drawing with graphite paper to your watercolor paper.

DIY Transfer Paper

To make your own transfer paper, cover the back of medium-weight tracing paper using a pencil or powdered graphite. Smudge the graphite around the paper, then soak bestine or lighter fluid on a cotton swab and rub the graphite. This causes the graphite to adhere to the paper. It is less likely to smudge or smear onto your watercolor paper but easily transfers to another page when pressed with a sharp pencil. If you are concerned with the graphite showing through your painting, use a colored pencil or pastel (instead of graphite) that is compatible with the colors with which you plan to paint. The lines will be less likely to distract.

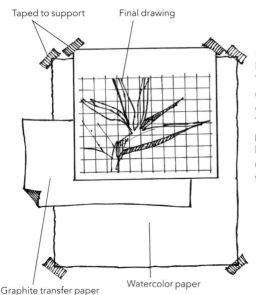

Taped to support Final drawing

Graphite transfer paper Watercolor paper

Using Transfer Paper

Position a sketch or drawing on watercolor paper. Tape down the watercolor paper and sketch so they don't shift while transferring the drawing. Slide the graphite sheet facedown between the two papers. Trace the drawing with a 2H or 3H pencil. A sharp pencil will transfer a clean thin line. Don't press too hard or you will score the watercolor paper. Before removing the drawing, check that everything has transferred.

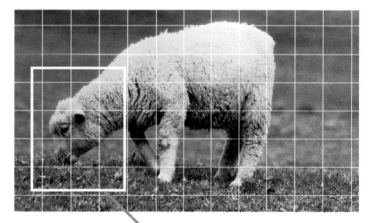

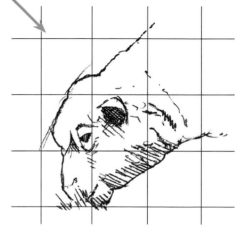

Using a Grid

Place a grid of any dimension over the reference. The grid on the sheep is based on a ½" (12cm) scale. By doing this you have created a series of reference points that can transfer to a larger or smaller grid. Follow as many of these points as possible and you will have successfully enlarged or reduced the reference.

Saturated and Unsaturated Colors

Saturation describes the vividness of a color. Pure colors (those that represent the red, yellow and blue colors on the color wheel) such as Cadmium Yellow, Permanent Rose and French Ultramarine are highly saturated. An unsaturated color has low purity and is dull; grayed colors have low saturation.

USING SATURATED COLORS

To make a saturated color appear brighter or more intense, place it in an area surrounded by neutral or unsaturated colors. Use this technique when painting landscapes or tonal paintings. Try painting the majority of the picture in unsaturated, muted colors with the focal point in bright, saturated colors. Using too many highly saturated colors causes them to compete with one another, making it difficult to focus on the center of interest. Saturated colors do not allow the viewer's eye to travel smoothly through the painting and cause the eye to bounce from one intense color to the next.

MIXING SATURATED COLORS

When you mix a highly saturated color with another color, it loses saturation and will never recover its full vividness. Two saturated colors that are next to each other on the color wheel begin to lose saturation when mixed together. Mixing a complementary color with a saturated color immediately causes the saturated color to lose its intensity. You can also use a black, neutral tint or earth color to make an unsaturated color. Such additions begin to change the hue, which may or may not be the desired effect.

Color Names

Staining colors are generally considered highly intense or fully saturated colors. These intense colors often have a trade name such as Winsor Yellow (Winsor & Newton) or Thalo Blue (Grumbacher). Colors that are considered unsaturated are earth colors such as Yellow Ochre, Burnt Umber, Brown Madder, Alizarin Crimson, Olive Green and Indigo.

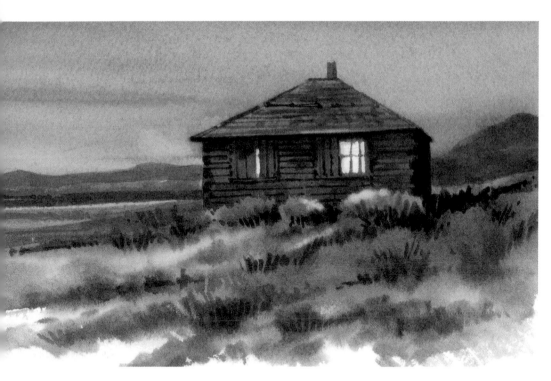

Emphasizing Saturated Colors

In this painting I used unsaturated colors to create an evening setting. Then I emphasized the window with the saturated color of Cadmium Yellow. I also lifted color from the brush area below the window and glazed a little Cadmium Yellow back into the area of lifted color. This gave the effect of light coming through the window.

End of the Day
Watercolor on 140-lb. (300gsm)
cold-pressed paper
4½" × 7¼" (11cm × 18cm)

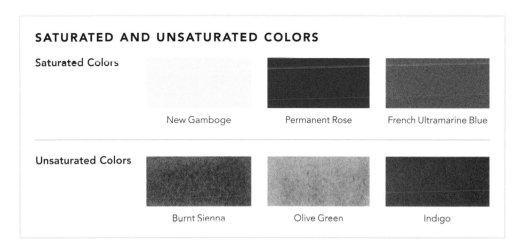

SATURATED AND UNSATURATED COLORS

Saturated Colors

| New Gamboge | Permanent Rose | French Ultramarine Blue |

Unsaturated Colors

| Burnt Sienna | Olive Green | Indigo |

Transparency and Opacity

The characteristic of each watercolor varies from extremely transparent to opaque. The transparency of a hue is determined by how much light goes through the pigment and is reflected back to the surface of the paper to the viewer's eye.

TRANSPARENT COLORS

Transparent colors mix well with other colors and reduce the opacity of opaque colors. Glaze an opaque colors over transparent colors because the pigment of an opaque color lays on the surface and is more easily lifted or reactivated when you apply a wash over it.

Discover Color Characteristics

Practice glazing with different pigments, transparent colors over transparent colors or opaque over transparent colors. See how the color tends to lift if you glaze a transparent color over an opaque. Create "mud" and see how flat and dull the color is. The key to success is practice. The more you understand the paints, the more success you will have in painting!

Paper Surface

The paper surface absorbs transparent colors more than opaque colors, but it depends on how much sizing the paper had. Glazing transparent colors has a greater effect on the paper with little or no surface sizing (soft paper) than paper with a lot of surface sizing.

OPAQUE COLORS

Opaque and semiopaque colors work a little differently. They allow less light to reach the paper surface, making them look less vibrant. Particles of the pigments lay on the paper surface, causing three specific effects:

1. Mixing two or more opaque colors can produce "mud," which dulls transparency.
2. Opaque and semiopaque colors can generally be lifted or reactivated.
3. Granulation is a wonderful texture created by the pigment settling from a wash into the low areas of the paper, and can occur with opaque colors. Experience teaches which pigments granulate and how much water to use to create this effect.

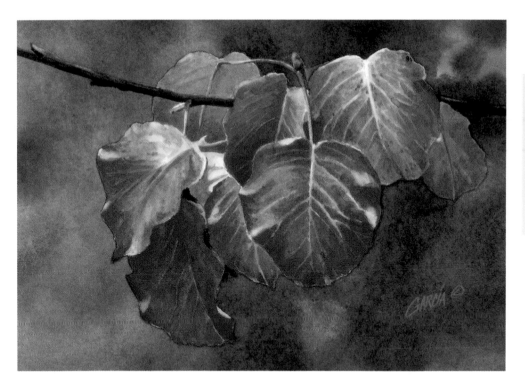

Painting With Multiple Transparent Colors
I painted these leaves with transparent Winsor & Newton Aureolin Yellow, Permanent Rose, Alizarin Crimson and Mauve.

Fall Color
Watercolor on 140-lb. (300gsm) cold-pressed paper
5¾" × 8" (15cm × 20cm)

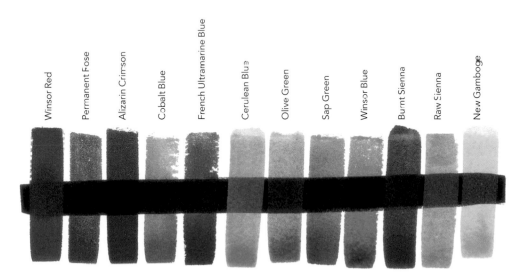

Winsor Red • Permanent Rose • Alizarin Crimson • Cobalt Blue • French Ultramarine Blue • Cerulean Blue • Olive Green • Sap Green • Winsor Blue • Burnt Sienna • Raw Sienna • New Gamboge

Opaque and Transparent Color Characteristics
Each manufacturer's hue varies in transparency and opacity. Create a color chart to become more familiar with each color's transparency. Paint a bar of black waterproof India ink. Allow the ink to dry thoroughly. Paint swatches of color over the black bar. When the paint dries, you will be able to see the transparency or opacity of each color.

Staining and Nonstaining Colors

Learning how the color reacts to your surface is critical to the success of your painting. Colors have the property to stain or not stain. This characteristic affects the techniques that you use in your paintings. For example, if you want to lift out paint the way I did in the sky area of *Homeward Bound* it's best to use a non-staining color.

NONSTAINING COLORS

Nonstaining colors tend to be the most versatile of the hues. They have the most ability to create luminosity, the extent to which light passes through the pigment, strikes the painting surface and is reflected back to the eye. Glazes and washes of nonstaining pigments always capture this luminosity.

STAINING COLORS

Staining colors soak into the surface and cannot be totally removed. You can scrape, scrub or sand the surface, but it will still retain some of the pigment. Add the staining pigment last because it greatly influences the color with which you mix it—a little pigment goes a long way. Staining colors mix well together. They are highly transparent, and when mixed as glazes they retain their luminosity.

SURFACE AND SIZING

This staining ability is also affected by the painting surface. Three hundred pound (640gsm) paper absorbs a stain more deeply than lighter-weight paper does. It is much more difficult to lift a color—staining or nonstaining—from this paper than from the surface of a 140-lb. (300gsm) paper. Sizing also affects the staining ability of a color. Surface sizing does not allow as much of the pigment to be absorbed into the paper. A softer, more absorbent inner-sized paper receives a stain more readily. You can buy a commercially made sizing agent and apply it to the paper to make it less absorbent.

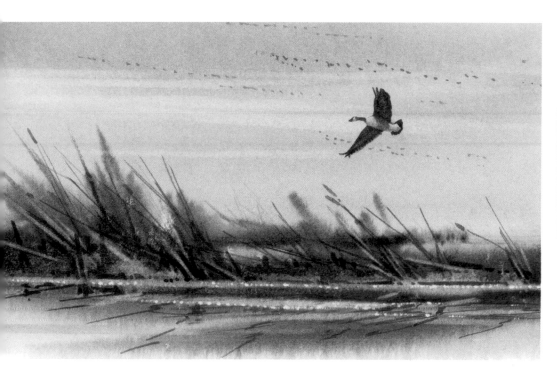

Work With Staining and Nonstaining Colors

I painted the sky with transparent Winsor & Newton Permanent Rose and Cobalt Blue, and the grass and reeds with Winsor & Newton Sap Green and Brown Madder. I used a flat, soft ¾-inch (19mm) flat to lift color.

Homeward Bound

Watercolor on 140-lb. (300gsm) cold-pressed paper

4½" × 7¼" (11cm × 18cm)

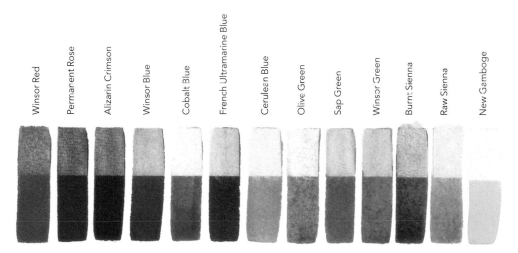

Winsor Red · Permanent Rose · Alizarin Crimson · Winsor Blue · Cobalt Blue · French Ultramarine Blue · Cerulean Blue · Olive Green · Sap Green · Winsor Green · Burnt Sienna · Raw Sienna · New Gamboge

Staining/Nonstaining Color Chart

With each color on your palette, paint an approximately ½" × 1¾" (12mm × 44mm) swatch. Allow the colors to dry thoroughly. Mask out approximately half of the swatch with masking tape. Now use a damp brush to scrub out as much pigment as possible without damaging the surface. With a paper towel or facial tissue, gently lift the moisture from the scrubbed area. Arches watercolor paper holds up best to the abuse of scrubbing and taping. Be extremely careful when removing tape from a softer paper.

Wet-into-Wet

The wet-into-wet wash—painting on a wet surface and letting colors blend as they may—is the essence of transparent watercolor painting. I like to call it "controlled accidents." Control comes from knowing the amount of water on the surface and how to use it. Paper texture and weight also play roles. On hot-pressed paper, colors float and remain on the surface. Cold-pressed and rough papers are more absorbent.

A wet-into-wet wash looks strong and vibrant while wet but loses intensity when the colors dry. Always make your washes stronger to compensate.

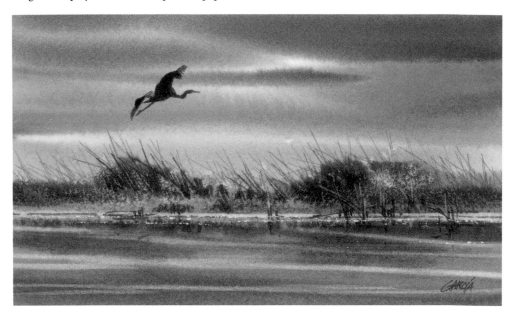

Create Soft Effects With Wet-Into-Wet Washes
I covered the surface with a wet-into-wet wash. As the wash dried, I added color to create the soft effect of the brush, still working wet-into-wet. I applied salt to add texture. When the paper was completely dry, I added the reeds and heron and then glazed over the entire lower portion of the painting to differentiate the value from the sky. The glaze helped bring this area forward. It is easier to control the richness and intensity of the wash when working with a small painting. A large painting requires more paint to be mixed, which tends to become diluted when placed on the wet surface of the paper.

Day's Final Light
Watercolor on 140-lb. (300gsm) cold-pressed board
4¾" × 8" (12cm × 20cm)

Wet-Into-Wet Wash

1. Completely saturate the paper with water. Be careful to wet the surface evenly; this affects the success of the wash. Mix a large solution of color on the palette. Use the largest appropriate size brush available to apply the color. If it's too wet, you have little control of the wash; too dry, and the wash will not flow freely.

2. While the surface is wet, add a second and third color. If the wash is doing what you want, lay the painting flat and allow it to dry. If you want more blending, pick up the wash and tilt and move it to control the flow of color on the surface.

3. When the desired effect is reached, allow the painting to dry. If you use a hair dryer to dry the surface, be careful not to blow the wash around.

Wet-Into-Dry

A wet-into-dry wash is another term for a glaze, or layering wash. This term, wet-into-dry, can be applied to any wash that is applied to a dry surface. When doing a wet-into-dry wash, try not to reactivate or lift pigment that has already been applied to the paper. A very transparent wet-into-dry wash creates a third color or value when glazed over a wash. A wet-into-dry wash glazed over an overactive texture subdues the texture but allows it to be seen.

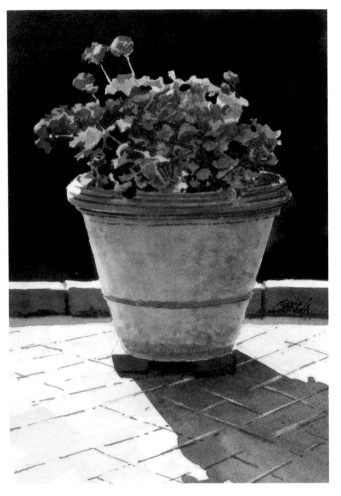

An Italian Bouquet
Watercolor on 140-lb. (300gsm)
cold-pressed paper
8" × 5½" (20cm × 14cm)

Build Color and Value
I painted the terra-cotta pot with a series of wet-into-dry washes, starting with Aureolin Yellow and Permanent Rose, followed by a final wash of Cobalt Blue and Permanent Rose to create the shadow on the pot. I painted the green leaves with a series of washes layered to create negative and positive shapes. The floor is a series of very transparent wet-into-dry washes of New Gamboge and Permanent Rose. I painted the dark cast shadow with a wet-into-dry wash of Cobalt Blue, Permanent Rose and French Ultramarine. Much care was taken to avoid reactivating the lower washes.

EXAMPLES OF WET-INTO-DRY WASHES

This is a series of wet-into-dry washes. Apply Aureolin Yellow on three-fourths of the paper and allow it to dry. Next glaze a wash of Permanent Rose over part of the Aureolin Yellow. Glaze a transparent wash of Cobalt Blue over the yellow and red. All are wet-into-dry washes.

Paint a wet-into-wet wash of Cobalt Blue, Burnt Sienna and Olive Green. When this wash is completely dry, apply a dark wet-into-dry wash of Sap Green and French Ultramarine Blue. Use this technique to layer values and create negative or positive shapes.

Subdue a very busy wet-into-wet wash of Cobalt Blue, Brown Madder and salt texture with a wet-into-dry wash. Glaze the first wash with French Ultramarine Blue, allowing a small amount of texture to show through. This technique can be controlled by the transparency of the wet-into-dry wash. Don't reactivate the texture.

Drybrush

Drybrush is brushwork done on the dry surface of the paper. This technique is influenced by the type of paper and brush used and the creativity of the artist. Smooth paper (hot-pressed), lightly textured (cold-pressed) and heavily tex-tured (rough) respond differently to dry-brush textures. You can push, pull, drag or dab paint to create dry-brush textures. It does not have to be done with a brush—try a sponge.

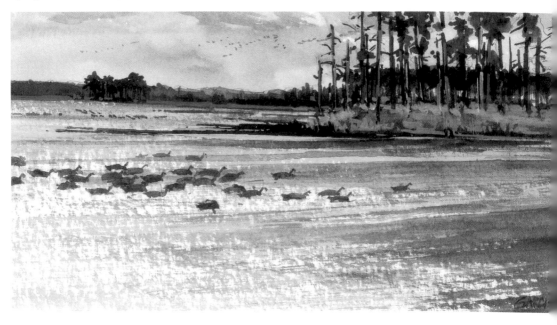

Show Direction With Drybrushing
I painted this on location with a dry-brush technique to emphasize the strong directional flow of the wind. I worked the painting from the background forward and painted the geese last. I dragged a partially loaded brush from right to left several times, lifting each stroke slightly while applying less pressure. The dragging caught the paper texture and created the choppy water. A steady, quick hand is required.

Cold West Wind
Watercolor on 140-lb. (300gsm) paper
4" × 7½" (10cm × 19cm)

EXAMPLES OF DRY-BRUSH TECHNIQUE

Drag a ¾-inch (19mm) flat, loaded with pigment across the surface of the paper. Layer various colors over the surface to create an old board or wood texture. A little sponge or spattering adds to the effect.

Drag a flat brush across the surface. Encourage the strokes to blend together. Turn this texture in different directions. It could be the texture of a waterfall or the sparkle on the surface of water.

Pull a large round brush over the surface of the paper. Cold-pressed 300-lb. (640gsm) paper works well for these textures.

Flat Washes

A flat wash is made from brushing successive strokes of color on a wet or dry surface. Each stroke is placed next to the other, creating an even layer of color. Of the three washes—gradated, variegated and flat—the flat wash is the easiest to do. All three washes can cover an entire sheet of paper or be placed in a very specific area. Use a large round or flat brush to apply the wash. Use the tip or end of the brush so its heel doesn't damage the soft, wet paper.

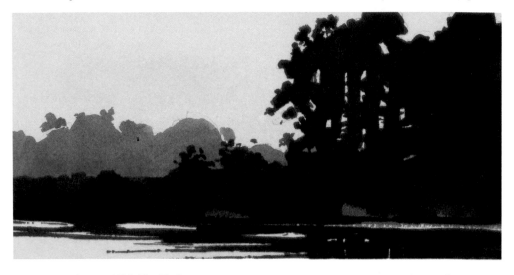

Painting Landscapes With Flat Washes
I used a 1-inch (25mm) flat to apply a flat wash of a mixture of Indian Yellow and Raw Sienna. I saturated the watercolor paper with clean water to keep the wash from drying too quickly. The middle ground is a flat wash of Cobalt Blue, Viridian and Permanent Rose in a medium value. In the final step I added a rich mixture of Alizarin Crimson, French Ultramarine Blue and Winsor Green as a silhouette in the foreground. This is a flat wash with a little variation to add interest.

Low Country Sunset (Sketch)
Watercolor on 140-lb. (300gsm) cold-pressed paper
4" × 8" (10cm × 20cm)

Creating a Flat Wash

1. Mix a large amount of color on your palette—more than you expect to use.

2. Start at the top and quickly brush horizontally to the bottom of the wash.

3. Fill in the desired area as evenly as possible. Try to keep a consistent amount of moisture from top to bottom.

4. Use vertical strokes to recover the area. Be careful to keep the wash transparent.

5. Pick up the wash and tilt it from side to side and top to bottom to eliminate unwanted brushstrokes. If paint builds up along the edge, lift it out with a damp brush.

Gradated Washes

The value in a gradated wash changes from dark to light. Add water to dilute the pigment and make the value change. You can create a smooth transition with practice, but it's not always necessary. This wash can be started on a wet or dry surface. It is generally easier to work on a premoistened surface.

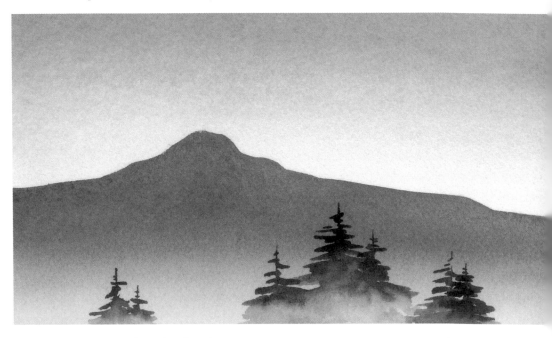

Painting a Landscape With Gradated Washes
The sky wash is Cobalt Blue on a premoistened surface, applied with a 1-inch (25mm) flat. Add water to dilute the color as you work it down the wash. Pick up the paper and tilt it from side to side, top to bottom to eliminate unwanted brushstrokes. Allow the wash to completely dry.

The mountains are a wash of French Ultramarine Blue applied in the same manner as the background. Remove excess water with a tissue, paper towel or damp brush to prevent blossoms on the edge of the wash.

The trees are a gradated wash applied unevenly. Do this by adding water to the wash without allowing it to even out.

Mountain and Trees (Sketch)
Watercolor on 140-lb. (300gsm) cold-pressed paper
4" × 7" (10cm × 18cm)

Creating a Gradated Wash

1. Apply a rich stroke of color to the top of the wash. Use a large round or flat brush.

2. Begin to dilute the color by adding clean water to the wash. Start to work toward the bottom of the wash.

3. Move down and continue adding clean water to the wash. When you reach the bottom, there should be a slight amount of pigment left in the wash. Practice eliminating unnecessary brushstrokes. If streaks appear, the surface is too dry. Remember to pick up excess water.

Variegated Washes

A variegated wash is a type of wet-into-wet wash. The variegated wash tends to place colors side by side; then mix and blend them only along their edges (whereas a standard wet-into-wet wash blends much more of the overall color).

Use Variegated Washes for Wet-Into-Wet Texture

Apply the wash top to bottom using Cobalt Blue and a mixture of New Gamboge and Permanent Rose. Wet the surface before applying the color. Control the blending to maintain the variegated wash. Paint the silhouette of the boat with a mixture of Alizarin Crimson, French Ultramarine Blue and Winsor Green.

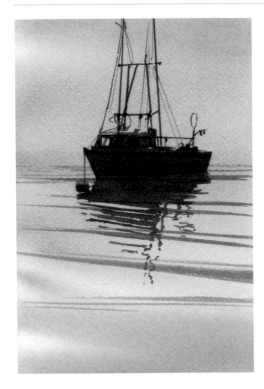

At Anchor
Watercolor on 140-lb. (300gsm)
cold-pressed paper
7½" × 5" (19cm × 13cm)

Use Two Washes

This is a combination of wet-into-wet and variegated washes. The sky is a soft wet-into-wet wash, allowing the colors to blend softly together. The line of foliage, while still a wet-into-wet wash, shows more control and the colors only slightly blend. The Olive Green edges also softly blend with the Burnt Sienna in this controlled manner.

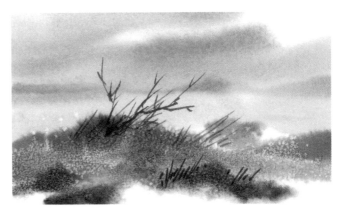

Brush Line (Sketch)
Watercolor on 140-lb. (300gsm) cold-pressed paper
3" × 6" (8cm × 15cm)

Creating a Variegated Wash

1. On a damp, saturated paper, place areas of Sap Green and Raw Sienna side by side.

2. While the surface is still wet, add Cerulean Blue. There should be enough moisture left on the surface to allow the colors to slightly blend.

3. Pick up the wash and tilt it side to side, back and forth to control blending.

Glazing and Layering

Glazing and layering are basically the same process. They change value and direct the viewer's eye. Glazing uses very thin, transparent washes of one color over another color. Glazing with a warm transparent color creates a luminous, glowing glaze. Starting with a cool color gives a heavier, denser glaze. Use glazing as a means to unify a painting, add mood or change areas of color.

Use layering to apply premixed colors over another wash to change values or intensity. Layering is also used to direct the eye through value placement.

CONTROLLING TECHNIQUE

To glaze and layer, start with a completely dry surface. Premix your colors on a palette and keep brushstrokes to a minimum or the underlying pigment will reactivate and blend with the glaze, destroying the luminosity you are trying to achieve. Glazing and layering are more easily controlled on heavier watercolor paper. This paper absorbs the pigment more deeply, and the paint is reactivated less easily. On a smooth surface, color lifts easily but is more difficult to glaze.

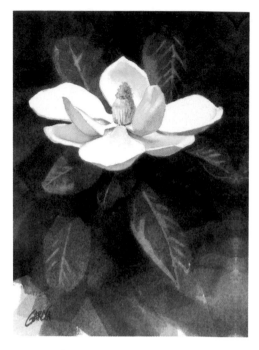

Create a Flower With Layers and Glazes
I drew the flower and leaves with a 3H pencil, arranging the leaves to lead the viewer's eye into the painting. I created the shadows on the flower petals with a series of glazes, starting with Permanent Rose, then Raw Sienna and finally Cobalt Blue. This creates a rich, transparent shadow color. I layered rich premixed color to create deep, dark values in the background to control eye movement. I lifted color to highlight the leaves.

Hibiscus Flower
Watercolor on 140-lb. (300gsm) cold-pressed paper
8" × 5½" (20cm × 14cm)

Glazing and Layering

GLAZING

1. Paint very thin transparent bars of color on your paper; I used Permanent Rose, Cobalt Blue and Aureolin Yellow.

2. Paint thin glazes, using the same colors across the original bars. Note how values change and secondary colors are created. When warm colors are below the cool glaze, colors are more vibrant and transparent.

Repeat the exercise, combining the three original colors with three new colors. Try this with all your favorite colors.

LAYERING WASHES

1. Create a wet-into-wet, gradated or flat wash. Let it dry.

2. Glaze a premixed color or value over the original wash.

3. Glaze or layer a series of washes over the initial wash to build up values. Too many layers will result in an opaque, flat finish. Be careful not to reactivate the earlier washes.

Brushwork

Brushwork can be as varied and creative as the artist chooses. Round, flat, bristle, synthetic and sable brushes all serve various purposes in the hands of the artist. They become the artist's creative tools. Experience will help you decide which brushes work best for you. 80-percent of the time I use two flats—¾-inch (19mm) and 1-inch (25mm)—and three rounds—nos. 4, 6 and 8. I keep old brushes for scrubbing and lifting. Generally, rounds are for detail, and washes and flats are for washes and texture, but they are often interchangeable. I use synthetic brushes almost exclusively because they are durable, can take a lot of punishment and are inexpensive to replace. Time and your technique will dictate your choice of favorite brushes.

Palette Knives

Using a palette knife is not a technique recommended for soft paper.

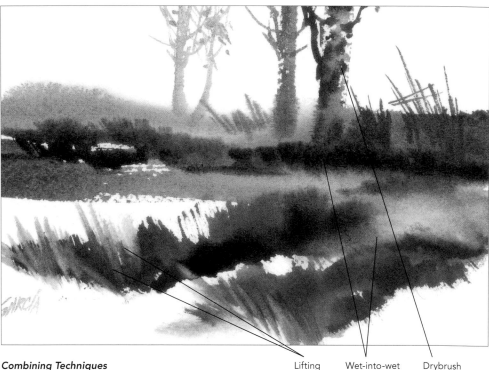

Combining Techniques
Take a few minutes to experiment with texture on a piece of scrap paper. This sketch illustrates a wet-into-wet wash, drybrushing, lifting, scrubbing and dabbing with a variety of brushes.

Lifting Wet-into-wet Drybrush

Hold a 1-inch (25mm) flat vertically and pull down to create dry-brush textures.

Create these textures with nos. 6 and 8 rounds.

Use a liner for the thin textures. Cut the tip of an old no. 6 round and press it down on the paper to create the texture using Raw Sienna.

Create these textures with a rigger brush.

Create these textures with a palette knife; while the paper surface is still damp, remove paint with the knife tip.

Use the palette knife to add pigment to the paper surface.

Palette Knife Textures

Place a wet-into-wet wash on the paper; wait until it has dried slightly to damp. Use the knife like a squeegee (a credit card will also work) and drag it across the page. If any part of the paper is too wet, the pigment and water will flow back over it, leaving a dark scar. Create the twigs at the base of the rocks by pulling the tip of the knife through the damp paint. Create the texture above the rock by loading the knife edge with paint and pulling it across the paper.

Lifting Paint

Lifting paint can correct mistakes, develop textures, create highlights and change values in a painting. You can lift paint while it's wet or dry. A wet surface that has not allowed all the pigment and color to settle lifts more easily. While the surface is wet, use paper towels, tissue, sponges or brushes to lift color. A dry surface requires more work. First rewet the pigment, then gently scrub.

Painting Surfaces

The type of painting surface you're working on influences lifting. Color lifts immediately from hot-pressed paper, but 300-lb. (640gsm) cold-pressed and rough paper absorb the pigment and make lifting color more difficult. Lifting can damage softer papers.

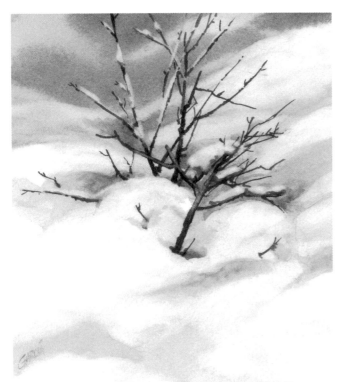

Lifting Color With a Brush

I placed a soft wet-into-wet wash of Cobalt Blue, Permanent Rose and Raw Sienna on the paper. As the pigment settled into the paper I used a ¾-inch (19mm) synthetic flat brush to lift color. As the wash continued to dry, more edges were defined. Where appropriate, I used tissue to lift additional color. After the surface was completely dry, I painted the branches and, with a small no. 2 synthetic brush, lifted off color around the branches.

Deep Snow

Watercolor on 140-lb. (300gsm) cold-pressed paper
6½" × 5½" (17cm × 14cm)

PRACTICE LIFTING COLOR

Use a soft synthetic brush to lift color from a dry, wet-into-wet wash. Use a tissue and synthetic brushes of various sizes to pick up the reactivated pigment.

Drop water onto a damp, wet-into-wet wash. Use a soft synthetic brush to gently scrub and lift color.

Lifting Color With Tissue

It's also important for a watercolorist to learn how to use tissue or paper towels to lift color. Both work great for lifting color that a brush cannot and for creating interesting shapes. The lifting ability of paper towels and tissue differs greatly; tissue is much more absorbent. Have both available.

Shape paper towels and press onto the surface of the paper. Allow the pigment to soak into the surface and lightly stain the paper.

Use a soft tissue to create shapes. Lift immediately after the wash is applied to remove a majority of the wash.

Saving Whites

Learning to reserve the white of the paper is fundamental to watercolor painting and equally as important as learning about color and value. The white of the paper can add contrast, impact and highlights to a painting.

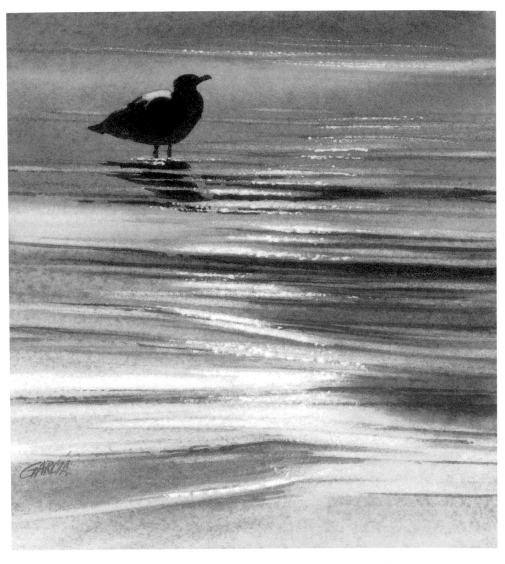

Practice Saving Whites

Create a rich wet-into-wet wash from Indian Yellow and Quinacridone Gold. Brush Mauve into the wash just before it dries to get the dark value. Then gently lift the color out of the wash using a clean, damp ¾-inch (19mm) flat; this brings out the white of the paper. After the surface dries completely, paint the bird in a dark value. Add the sparkle of pure white by drawing the tip of a utility knife across the paper's surface.

Golden Glow
Watercolor on 140-lb. (300gsm) cold-pressed paper
5¾" × 5¼" (15cm × 13cm)

PRACTICE SAVING WHITES

Paint around an area to reserve the white paper. If the paper is dry, the paint or water won't run into it. The darker the background, the more contrast.

Paraffin reserves the white of the paper and adds texture. Not all of the wax will lift from the surface; however, placing paper towels over the wax and heating them with a hot iron removes most of the wax.

Paint wet-into-wet washes up to a dry area. Drop clean water into this dry area and allow it to flow out into the wash. If the wash is almost dry, a blossom will occur. Keep the area on the right white by using a tissue to stop the pigment from flowing into the water.

Coarse sandpaper removes pigment and brings back the white, though it severely damages the paper.

Masking tape, placed on the lower area, preserves the white.

Use the point of a utility knife or razor to scrape and scratch the surface of dry paper. This removes the paint and leaves a broken sparkle texture. Lifting with a bristle brush gives a soft highlight effect.

Use an old dampened synthetic or bristle brush to scrub the area. Use a tissue or paper towel to pick up the reactivated pigment.

Use a ¾-inch (19mm) flat brush to lift color in a specific direction. Carry or lift the white into the darker surrounding value.

Splattering

Splattering paint is a useful technique used to create rocks, old paint, rust and old wood textures. You can also use splattering to create foliage or a loose foreground.

TOOLS AND TECHNIQUES

A toothbrush or a flat, round, bristle or synthetic brush all work well for splattering. If you hold a flat brush horizontally to the paper, you can concentrate the splatter. Holding the brush vertically to the paper creates a long line of paint. Splattering paint onto a wet, damp or dry surface gives three distinct results. A toothbrush leaves a small, uniform texture. A bristle brush produces a larger, more spontaneous texture. You can also splatter different colors together. Use a paper towel and gently lift away some of the damp splatter to change the value and intensity of the color. Try splattering with clean water onto a previously splattered area for an interesting effect.

Gauge Your Splatter

Before using this technique on a painting, practice on a piece of paper. This allows you to see how much paint is in your brush. How hard you flick the brush also determines the amount of paint splattered.

Paint from very wet on the top to dry toward the bottom, using a ¾-inch (19mm) flat. Notice how the excess water lifts and carries the pigment toward the damp area.

Splatter the top area with a toothbrush, and the bottom area with a 1-inch (25mm) flat bristle brush.

Top: Splatter paint into clean splattered water. Middle: Splatter various colors into one another. Bottom: Use a paper towel to lift color.

Salt Texture

Salt texture is a wonderful, spontaneous technique to use in watercolors. Salt crystals are like small sponges that absorb the water and paint. As the salt dries it leaves behind a texture. If the paper is very wet, most of the salt dissolves and leaves little texture. Damp paper creates a pronounced snowflake-like texture. Brush off the salt just before it dries, or it will stick to the surface of the paper. Also, the weight of the paper (how much water it absorbs) and the color used influences how the salt works. For best results, practice and experiment. The more familiar you become with this technique, the easier it will be to use.

Salt Controversy

The use of salt in paintings is controversial. The pH level of the paper is slightly lowered when salt dissolves and is absorbed into the fibers. Some believe that salt shortens the life of the paper and consequently the art.

Apply salt to a very wet surface. Most of the salt dissolves, leaving very little texture in the paint.

Apply salt to a damp surface. If the paper doesn't dry evenly, creating a variety of textures.

Apply salt to a damp surface. A small, delicate texture develops. Each spot is a grain of salt.

Stippling

Stippling is a very creative and useful technique but can be time-consuming in its execution. It ranges from black-and-white dot patterns to dabbing the surface with a bristle brush. Using ink or paint in a pointillism fashion creates the texture. You can create values, patterns and even colors by the density or proximity of each dot to the next.

Create a wide range of values with a black-and-white pattern using a new fine-point permanent marker.

Use Indian Yellow, Cobalt Blue and Alizarin Red to create the stipple pattern with various size dabs using a round synthetic brush.

Use an old bristle brush to create this stipple pattern. Dab on Aureolin Yellow and Cadmium Red with quick, vertical strokes.

Sponge

Sponges are versatile tools in painting the textures of trees, rocks and shrubs. Use it to paint with or to lift color off the paper. There are two types of sponges, natural and artificial. Natural sponges have wonderfully diverse surfaces. You may want to buy two or three because each has a unique surface texture. Most synthetic sponges are less textured and have a mechanical look to their surface patterns. Because sponges are so absorbent, you must mix up much more color than you would if using a brush. Apply the paint to a dry or damp surface with a sponge, pulling, dabbing or pushing to create unique textures or patterns.

Manipulate Your Sponge

One benefit of using sponges is that they can be cut or torn and shaped into more manageable painting tools.

Use a large natural sponge to create textures on first a damp, then a dry surface.

Load an artificial sponge with paint and dab it on the surface.

Load a large natural sponge with paint and pull it down and across the paper.

Masking Fluid

The basic use of masking fluid is to preserve the white of the paper. You can also use it to create textures. Use masking fluid to create everything from falling snow to water splashing on rocks to tree bark to fish scales. Masking fluid works well because you can apply it in many different ways and you can remove it easily.

TRY A TOOTHPICK

There are times when a toothpick or small stick works better than a brush for applying masking fluid. A toothpick leaves a thin long line of fluid on the paper. You can crosshatch with it or draw fence lines. I can create almost any linear texture by using this technique. A sponge is also a good tool for applying masking agent. If I dab the surface of the paper it leaves a very loose organic texture. This is good for masking out the highlights in trees.

Create Dynamic Textures

You can apply masking fluid with an array of tools. Use these tools to create a variety of textures:

- Flat brushes
- Round brushes
- Toothbrush
- Toothpick

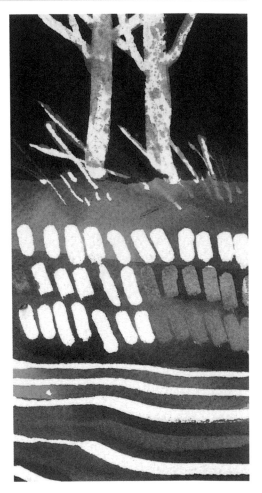

For the top, use an old brush to apply liquid latex to the two tree shapes. Let the latex dry. Gently rub the latex with your finger. Partially remove the latex creating a bark-like texture. Glaze Burnt Sienna over the area. Let the paint dry. Remove the remainder of the latex to complete the texture. For the middle sample, use the same concept of partially removing some of the dried latex. The texture was created by cutting the end off an old no. 4 round. For the bottom, apply liquid latex with a brush, but change the pressure to get a thin or wide line.

Use a toothbrush to apply masking fluid on the surface. Gently drag your thumb over the bristles of the toothbrush to get a fine splatter effect. Flick your wrist while holding a ¾-inch (19mm) flat brush to get the large splatter. Practice these two techniques on a piece of scrap paper to judge how much latex is on the brush.

Apply masking fluid with an old round brush to create negative and positive shapes.

Palette Knife

A palette knife is a good for removing wet paint or applying paint. Use the long edge or tip of a palette knife like a squeegee to push or pull paint away from a specific area. On very wet paper, paint may run back into the area where the palette knife is used, leaving dark lines which can be an interesting textural element.

Texturing with a palette knife will permanently dent the paper, so use a palette knife only when you are sure it will create the texture you want.

You can also paint thin and thick lines with a palette knife. Use the tip to paint branches, grass or fence posts. Use the edge to paint long thin lines such as wires or masts.

Before Using a New Palette Knife

A new palette knife has a thin coat of varnish on its surface to prevent rusting. Before using the knife, sand it or hold it against a flame to remove the varnish so that paint can cling to the blade.

Use the edge and tip of the knife on damp paper to subtract or remove paint from a specific area.

Use the tip and edge of the palette knife on very wet paper to make the pigment run back into the affected area.

Load paint on the tip or edge of the palette knife and pull it across the paper.

Alcohol

Alcohol used as a special effect is difficult to control because it evaporates and dilutes quickly, losing its ability to create texture. You can effectively apply only one wash over an area of alcohol. Additional washes dilute the alcohol, causing it to lose its ability to resist paint. Very wet paint will flow back into an alcohol area leaving a dark smudge or blemish. You can brush or splatter with alcohol either before or after the paint is applied.

Splattered Alcohol
Splatter alcohol on a clean dry surface. With a 1-inch (25mm) flat, paint over the area before the alcohol evaporates. Don't repeat with additional layers of paint because the alcohol will be diluted and won't work.

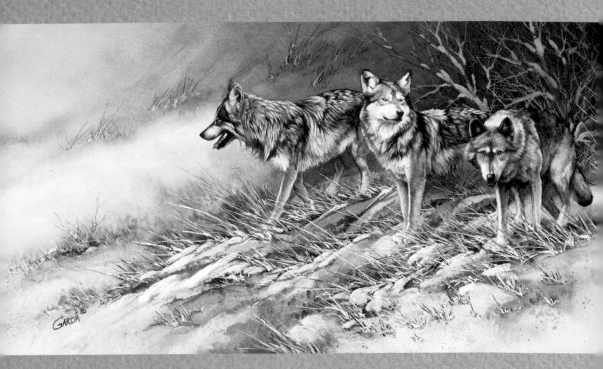

The Pack
Watercolor on 300-lb. (640gsm) cold-pressed paper
19½" × 40" (48cm × 101cm)

PAINTING POPULAR SUBJECTS

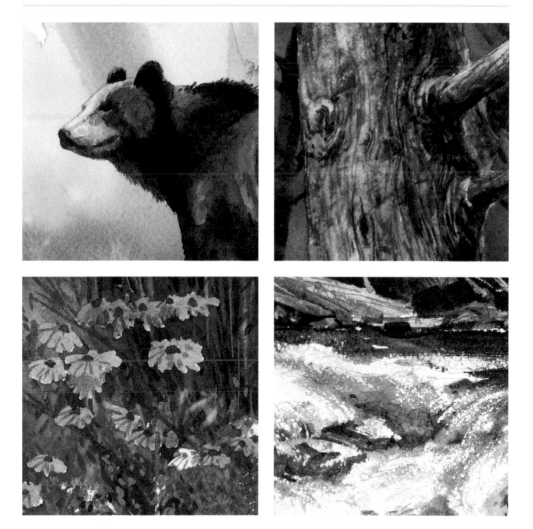

Black-and-White Dog

Convincing black fur is painted with multiple colors. I've used the white of the paper to represent white fur. For large dark areas, use a 1-inch (25mm) flat. As areas begin to dry, switch to the no. 6 round and add darker directional lines. Paint the more detailed areas of hair with the no. 4 or no. 2 round.

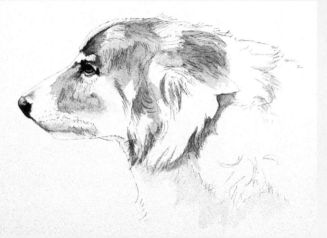

1. Draw, Then Paint Base Washes
Use a 3H pencil to make a drawing that shows the patterns of light and dark on Rocky's face. Use a light wash of Permanent Rose and Burnt Sienna to warm some areas. Add a light wash of Cobalt Blue, French Ultramarine Blue and Permanent Rose for the dark patterns.

Materials

BRUSHES
¾-inch (19mm) and
 1-inch (25mm) flats
Nos. 2, 4 and 6 rounds

WATERCOLORS
Brown Madder
Burnt Sienna
Cobalt Blue
French Ultramarine Blue
Permanent Rose
Quinacridone Gold
Sepia

GOUACHE
Titanium White (or
 Pelikan Graphic
 White)

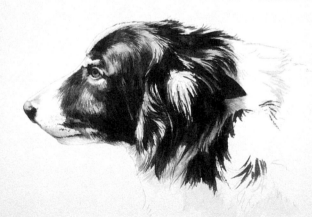

2. Define Lights and Darks
Mix French Ultramarine Blue, Brown Madder and Sepia; add this to the dark areas to define the facial patterns. The darker you paint an area, the lighter in value the adjoining area will seem. Now you can lift and soften some highlights in the dark areas. Warm the areas near the forehead and eye with a small amount of Burnt Sienna.

Highlight the Eye

Establish Fur Direction

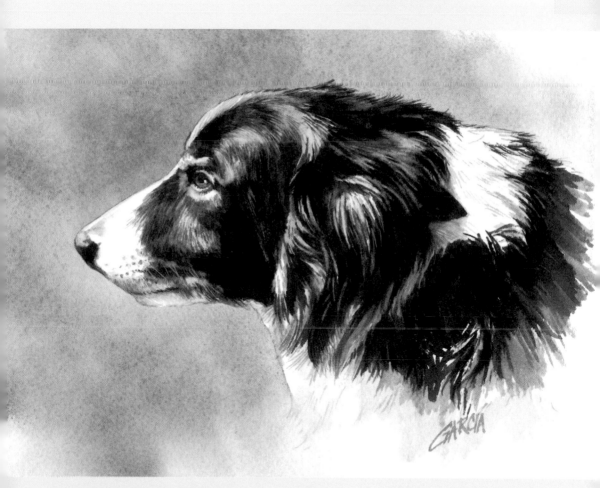

3. Add Fur Details and Background

Paint the fur with long thin strokes, indicating just a bit of light texture in the white fur areas. Let dry thoroughly. Brush clean water in the background up to the edge of the portrait. After the water has saturated the background, add a wet-into-wet wash of Quinacridone Gold, Cobalt Blue and French Ultramarine Blue. Let dry. Soften any hard edges. Finish by adding whiskers and eye reflections with gouache.

Rocky
Watercolor on 140-lb. (300gsm)
cold-pressed paper
5½" × 8" (14cm × 20cm)

Fat Cat

This painting requires a careful drawing that shows the place-
ment of shadows and changes in fur color.

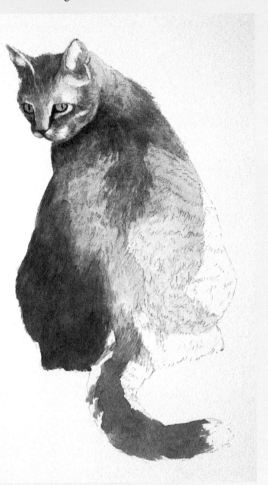

1. Draw, Then Paint Base Washes
Draw the cat, then saturate the drawing with a wash of water. Paint wet-
into-wet washes of Burnt Sienna, Sepia, and Cobalt Blue. As the washes
are drying, add more dark values around the nose and eyes and in the
shadow area under the jaw.

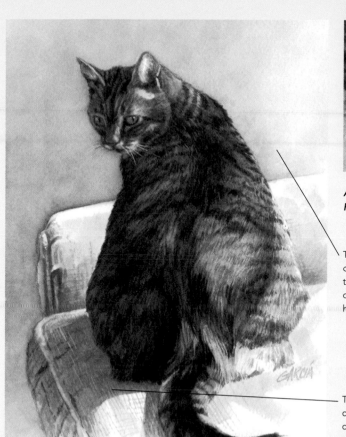

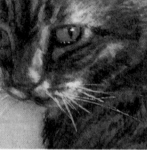

Add Whiskers and Eye Reflections With Gouache

The background must be dark enough to define the couch but not so dark as to lose Snaps' head and shoulders.

The shadow on the couch must follow the contours of both the couch and the cat.

2. Paint Fur Details and Background

Paint the fur with thin strokes following the direction in which the hair lies, working from light to dark values. Use Permanent Rose on the nose and inside the ear. The background and couch are a series of washes using Permanent Rose, Burnt Sienna and Cobalt Blue. Detail the sofa and soften hard edges. After everything dries, add whiskers and eye reflections with white gouache.

Snaps—Fat Cat, Sweetie Cat
Watercolor on 140-lb. (300gsm) cold-pressed paper
8" × 5½" (20cm × 14cm)

Snowy Owl

DEMONSTRATION

This painting captures the essence of the bird and is not meant to be an anatomical rendering. The general feeling must be right, but you don't have to show every feather.

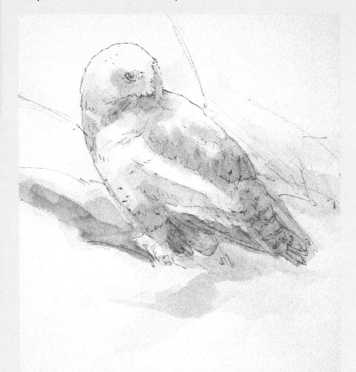

Materials

BRUSHES
½-inch (12mm) flat

WATERCOLORS
Alizarin Crimson
Cobalt Blue
French Ultramarine Blue
Permanent Rose
Quinacridone Gold
Raw Sienna
Winsor Green

1. Sketch, Then Lay On Washes

Sketch the owl very lightly. Loosely brush washes of Permanent Rose, Cobalt Blue and Raw Sienna over parts of the background and bird using a ½-inch (12mm) flat. Let dry. Add darker values and shadows, helping to define the shape of the bird and some of its feathers and facial features. These darker values are the same colors that were used over the background and bird; just use less water in the mixture.

2. Add Dark Values
The way to make an area white in a watercolor painting is to surround it with a dark, rich value. Note that this owl is almost completely surrounded by dark values. Use French Ultramarine Blue, Alizarin Crimson and Winsor Green to achieve the dark value here, with a bit of Quinacridone Gold in some areas. Paint shadows and weeds. Lift out a few final weeds using a ½-inch (12mm) flat.

Snowy Owl
Watercolor on 140-lb. (300gsm)
cold-pressed paper
7" × 6" (18cm × 15cm)

Bear

What does a bear do in the woods? He gets painted! This is an example of painting a loose, free-flowing, abstract design over the background before adding the subject. Use a 2H pencil for the drawing. Make sure the drawing is dark enough that it won't get lost in the wash.

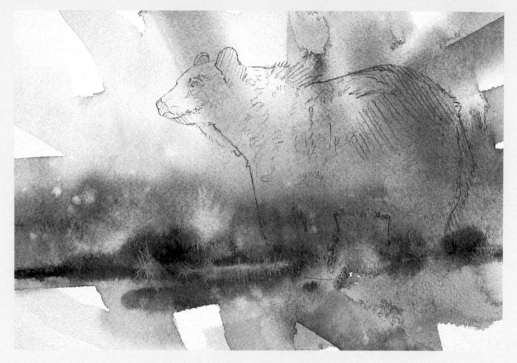

Materials

BRUSHES
¾-inch (19mm) and
 1-inch (25mm) flats
Nos. 2, 4 and 6 rounds

WATERCOLORS
Brown Madder
Burnt Sienna
French Ultramarine Blue
Olive Green
Permanent Rose
Sepia

1. Draw, Then Add Background Washes
Make a fairly dark sketch and saturate it with water. Paint background washes of Permanent Rose, French Ultramarine Blue and Burnt Sienna. Pull lines of color with a flat brush. As the water dries, paint Burnt Sienna, Olive Green and Brown Madder along the ground and make these colors flow upward by tilting the painting. Splatter a little clear water for additional background texture.

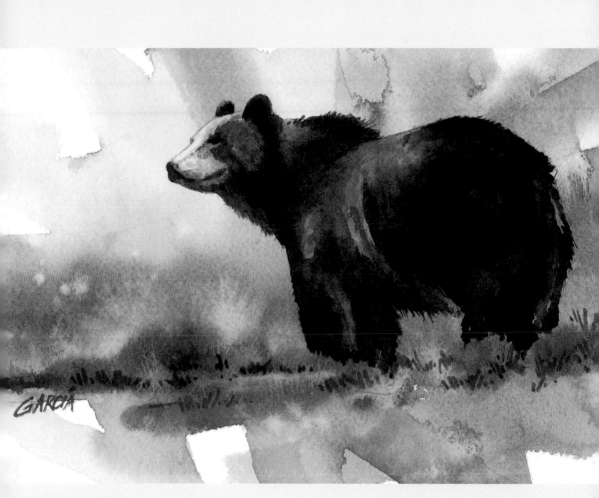

2. Paint the Bear

When the background is dry, cover the drawing of the bear with clear water. Apply a light wash of Burnt Sienna, Sepia, and French Ultramarine Blue on the damp surface. Build up the darker areas by adding stronger color. Paint the nose, ears and eyes, and create just a little fur detail around the outer edges of the bear. Try to achieve a loose, painterly effect with minimal detail. Add blades of grass with Olive Green.

Big Bruiser
Watercolor on 140 lb. (300gsm)
cold-pressed paper
5½" × 8" (14cm × 20cm)

Tree Bark

Painting tree bark requires close observation. Young trees tend to have smoother surfaces, while older trees are more textured. Most bark has a texture that runs up and down the trunk, but birch and aspen have black texture that runs around the tree. Trunk texture flows around limbs and knotholes; limb texture follows the direction of the limb. Study your subject carefully before you paint it.

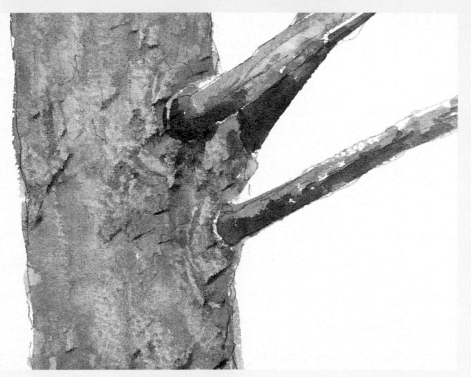

Materials

BRUSHES
¾-inch (19mm) flat
Nos. 2, 3 and 4 rounds

WATERCOLORS
Brown Madder
Burnt Sienna
Cobalt Blue
French Ultramarine Blue
Quinacridone Gold

1. Block in the Tree

Start the bark on this tree with light wet-into-wet washes of Cobalt Blue, Burnt Sienna and a little French Ultramarine Blue. As the wash begins to dry, lift some color out. Darken the shadowed undersides of the limbs. Vary the color of the wash by controlling the amount of Burnt Sienna used. If additional color is needed, add Quinacridone Gold while the painting is still damp. Proceed to the next step before the painting dries.

*Flow the Bark Texture
Around the Knothole*

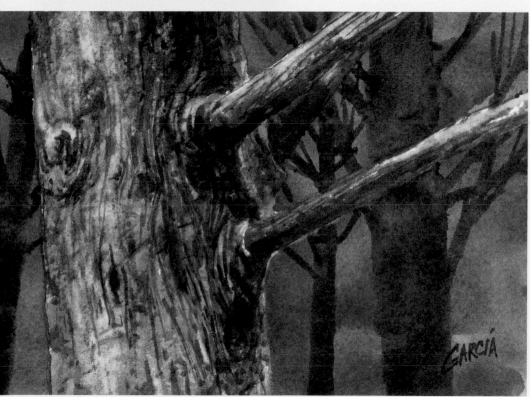

2. Add Shadow and Texture

Pull a palette knife over the damp surface to remove some paint from the highest points of the paper's texture. With a small round brush, add lines of texture that flow up the trunk, around the knotholes and along the limbs. Let dry, then paint the background wet-into-wet with Quinacridone Gold, French Ultramarine Blue and Cobalt Blue. Let dry. Paint the dark trees with a mix of French Ultramarine Blue, Brown Madder and a little Burnt Sienna.

Tree Bark
Watercolor on 140-lb. (300gsm)
cold-pressed paper
4" × 6" (10cm × 15cm)

Fir Trees

Firs have a very distinct conical shape and an easily recognizable silhouette. Work this painting loose to tight and light to dark to create the sense of atmospheric perspective.

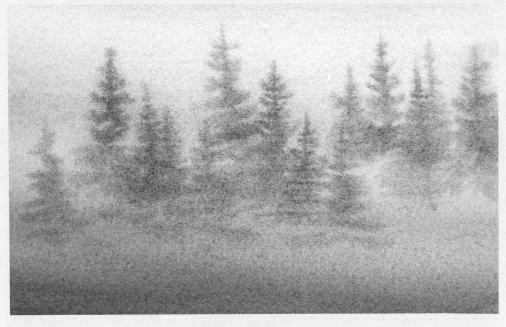

Materials

BRUSHES
¾-inch (19mm) flat
Nos. 3, 4 and 6 rounds

WATERCOLORS
Alizarin Crimson
Cobalt Blue
Cerulean Blue
French Ultramarine Blue
Olive Green
Sap Green

1. Paint the Background

Paint the top of the background with a wet-into-wet wash of Cobalt Blue, Cerulean Blue and Olive Green. Paint the bottom with French Ultramarine Blue, Cobalt Blue and Alizarin Crimson. Before the paint dries, use the darker wash color to paint soft-edged background firs. Time it so the paint spreads just enough.

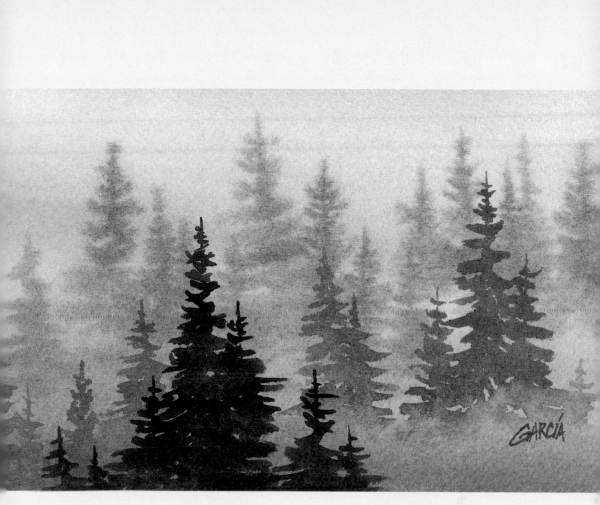

2. Add the Middle-Ground and Foreground Trees

Let the painting dry, then add the trees in the middle ground with a diluted mixture of French Ultramarine Blue, Sap Green and Alizarin Crimson. Add the dark trees to the foreground with a more concentrated mixture of French Ultramarine Blue, Sap Green and Alizarin Crimson.

Fir Trees
Watercolor on 140-lb. (300gsm)
cold-pressed paper
4¾" × 7½" (12cm × 19cm)

Foliage

When painting foliage, visualize it as a single mass rather than as branches or individual leaves. Do not paint detail you can't see from a distance, even though you know it's there.

Materials

BRUSHES
¾-inch (19mm) and
 1-inch (25mm) flat
No. 4 round

WATERCOLORS
Cobalt Blue
French Ultramarine Blue
Olive Green

1. Draw the Composition
Draw an oak tree with an H pencil. Indicate shadows with diagonal lines to create the three-dimensional shape of the tree. The cast shadow on the ground provides a base for the drawing.

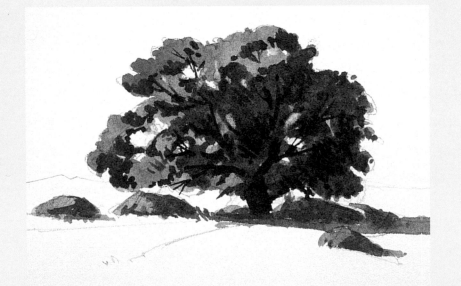

2. Add Flat Washes
Use flat washes to paint the overall shape of the tree and rocks. The foliage of the tree is a mixture of Olive Green and Cobalt Blue. After this wash dries, paint the shadow areas with Olive Green and French Ultramarine Blue. Add the trunk and branches. Let everything dry.

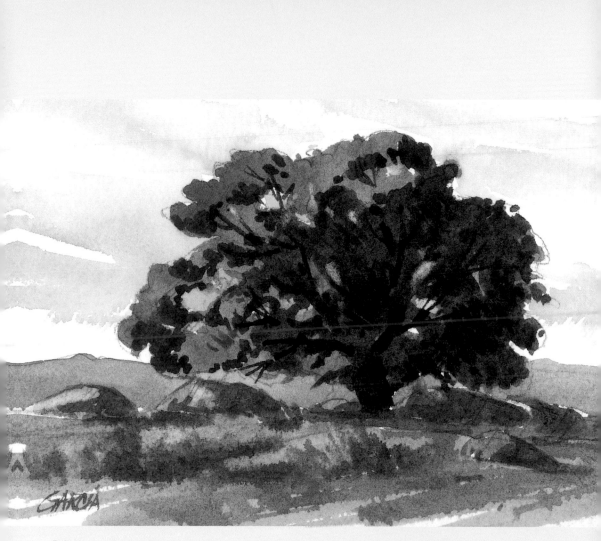

3. Paint the Sky and Mountains
Add the foreground, then the mountains with wet-into-wet washes in a quick loose technique. Drybrush the sky up to the edge of the tree with Cobalt Blue. Be sure to paint some blue sky amid the branches.

Foliage
Watercolor on 140-lb. (300gsm)
cold-pressed paper
4" × 5½" (10cm × 14cm)

Grass and Fields

Birds and fenceposts add depth and movement to this landscape painting.

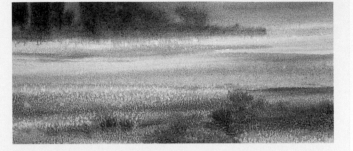

1. Paint the Foreground and Background
Paint wet-into-wet washes of Raw Sienna, Indian Yellow and Quinacridone Gold in the field and foreground; add a little Cobalt Blue, Sap Green and Brown Madder in the near foreground and in the background. As the paint dries, sprinkle salt across the foreground for texture. Brush off the salt just before everything dries.

Materials

BRUSHES
¾-inch (19mm) flat
No. 4 round

WATERCOLORS
Brown Madder
Burnt Sienna
Cobalt Blue
French Ultramarine Blue
Indian Yellow
Quinacridone Gold
Raw Sienna
Sap Green

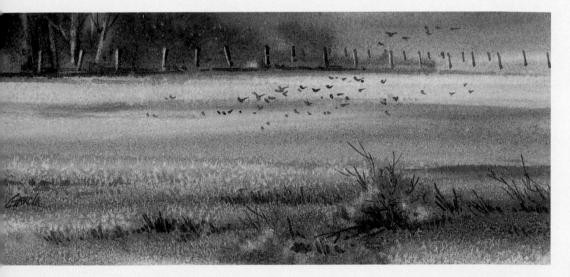

2. Add Detail
Indicate brush and grass with small brushstrokes. Paint the fenceposts and a few distant tree trunks with a mixture of Burnt Sienna and a touch of Cobalt Blue. Before the posts dry, use the tip of the palette knife to pull out some color from their entire lengths. Lift out the trees with a no. 4 round that has a worn tip. (The worn tip allows you to get a soft, thin line.) Add the birds with a mixture of French Ultramarine Blue and Brown Madder.

Grasses and Fields
Watercolor on 140-lb. (300gsm) cold-pressed paper
4½" × 10" (11cm × 25cm)

Distant Mountains

This painting is a series of gradated washes. The sky, each mountain range and the foreground are dark-to-light washes. Each wash after the initial one is done wet-on-dry.

Materials

BRUSHES
¾-inch (19mm) and
 1-inch (25mm) flat
Nos. 3, 4 and 6 rounds

WATERCOLORS
Alizarin Crimson
Brown Madder
Cerulean Blue
Cobalt Blue
French Ultramarine Blue
Permanent Rose
Sap Green

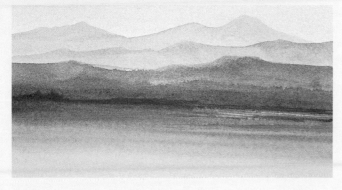

1. Paint Base Washes From Back to Front
Paint the sky using Cobalt Blue, Cerulean Blue and Permanent Rose. Let dry. Paint the mountains in stages with French Ultramarine Blue, letting the paint dry between layers. Add Sap Green and Alizarin Crimson to the mountain mixture to paint the middle ground. Paint the foreground as a very wet gradated wash using a 1-inch (25mm) flat, starting with the middle-ground color but adding Raw Sienna as you move down. Allow the horizontal brushstrokes to show.

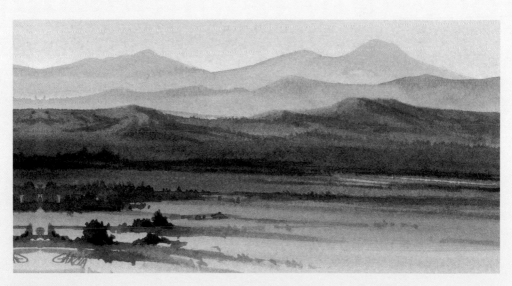

2. Add Details
Prepare a mix of French Ultramarine Blue, Sap Green and Brown Madder. Using a no. 4 or 6 round, quickly paint the trees in the foreground as silhouetted shapes. Add more water to the mixture to paint the more distant trees so that they are lighter in value. Subtly suggest detail on the closest mountain range.

Distant Mountains
Watercolor on 140-lb. (300gsm)
cold-pressed paper
4½" × 8½" (11cm × 21cm)

Rocks

Rocks come in all shapes, colors, sizes and textures. Take time to study your subject and plan your painting. Look for textures, values, shadows and how you might describe these elements on paper. Notice how shadows follow the shape of a rock and help show its volume. Once you've planned your approach, you can paint with a free, spontaneous technique.

Materials

BRUSHES
¾-inch (19mm) flat
Natural sponge

WATERCOLORS
Alizarin Crimson
Burnt Sienna
Cobalt Blue
French Ultramarine Blue
Olive Green
Raw Sienna
Winsor Green

1. Create a Sketch
Do a quick sketch with an HB pencil. Indicate the size and shape of the rocks. Use this drawing to indicate the shadows, which also shows you where the light is coming from in your scene.

2. Apply Texture
Use a natural sponge that has small irregular openings on its surface. With scissors, shape the sponge for painting. Gently dab a light mixture of French Ultramarine Blue and Alizarin Crimson on the surface. Vary the texture by rotating the sponge as you go. Paint the shadow with a wash of the same colors but more concentrated, using a ¾-inch (19mm) flat.

3. Paint the Foliage and Background
Paint the background with a wet-into-wet wash of French Ultramarine Blue, Alizarin Crimson and Winsor Green. Paint the foreground grass with a wet-into-wet wash of Raw Sienna, Olive Green, Burnt Sienna and Cobalt Blue, using a ¾-inch (19mm) flat.

Textured Rock
Watercolor on 140-lb. (300gsm) cold-pressed paper
4½" × 4½" (12cm × 12cm)

Flowers

Botanical gardens present the perfect opportunity to paint groups of flowers. Flowers of different colors and heights make for a more exciting painting.

Materials

BRUSHES
¾-inch (19mm) flat
Nos. 2, 4 and 6 rounds

WATERCOLORS
Burnt Sienna
Cobalt Blue
French Ultramarine Blue
Indian Yellow
Olive Green
Permanent Rose
Quinacridone Gold
Sap Green
Sepia

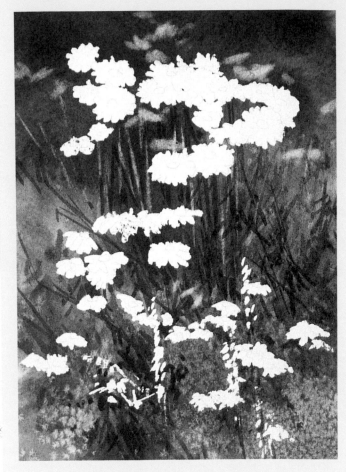

1. Mask the Flower Blooms
Draw a group of flowers and mask out the blooms with liquid masking agent. Let dry completely.

2. Paint the Background
Paint the background over the dry masking agent using a wet-into-wet wash of Olive Green, Sap Green, Quinacridone Gold and French Ultramarine Blue. As this wash dries, add a little salt to the foreground for an organic texture. Let dry, then add shadows and the indication of stalks and weeds. Lift some soft-edged blooms out of the background to show distance and overlapping. Let dry thoroughly, then remove the mask.

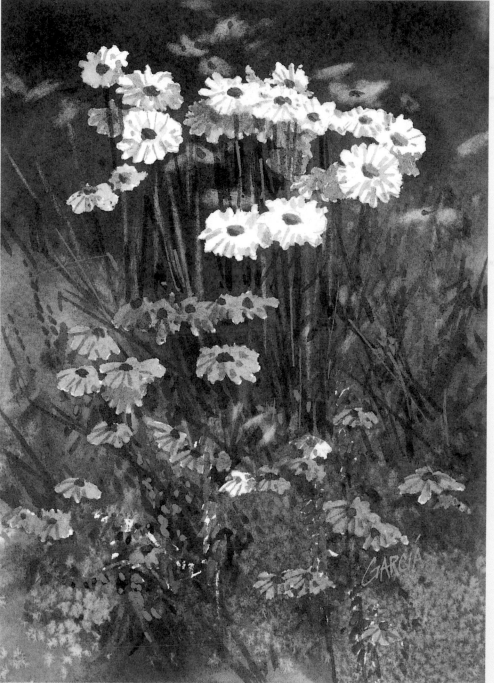

3. Detail the Flowers

Paint the yellow flowers with Indian Yellow for the petals and a Burnt Sienna-Sepia mixture for the centers. Paint red flowers with Permanent Rose. To the white flowers, add Indian Yellow centers and Cobalt Blue–Permanent Rose shadows.

Groups of Flowers
Watercolor on 140-lb. (300gsm)
cold-pressed paper
6¼" × 4" (16cm × 10cm)

Fluffy Clouds

Paint your clouds with personality. Fluffy clouds, not too dark and with soft edges, are just happy to be floating along. Be careful to not accidentally paint faces or recognizable features into clouds. Try painting these clouds by lifting color from the surface of the paper. You are less likely to create hard edges that will change their character.

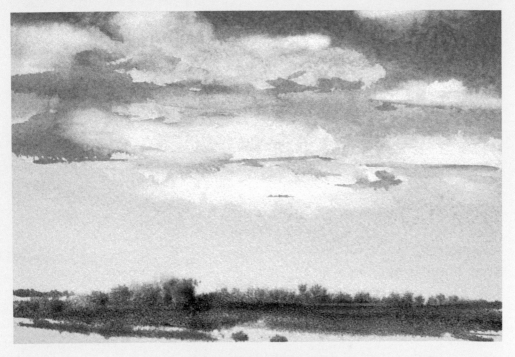

Materials

BRUSHES
¾-inch (19mm) and
 1-inch (25mm) flats
Nos. 3, 4 and 6 rounds

WATERCOLORS
Alizarin Crimson
Brown Madder
Burnt Sienna
French Ultramarine Blue
Olive Green
Permanent Rose
Raw Sienna
Sap Green

1. Block in the Sky, Clouds and Foreground

Paint a gradated wash with a mixture of French Ultramarine Blue and Alizarin Crimson, then add Raw Sienna to the bottom area of the painting. Before this lower area dries, apply Brown Madder, Sap Green and Olive Green; allow these colors to bleed out. Apply salt for texture. While the sky area is still damp, use a ¾-inch (19mm) flat and a tissue to scrub and lift out color. Begin to add shadows to the clouds. Paint the darker value of the sky with a mix of French Ultramarine Blue and Brown Madder; this helps the lighter areas of the clouds stand out.

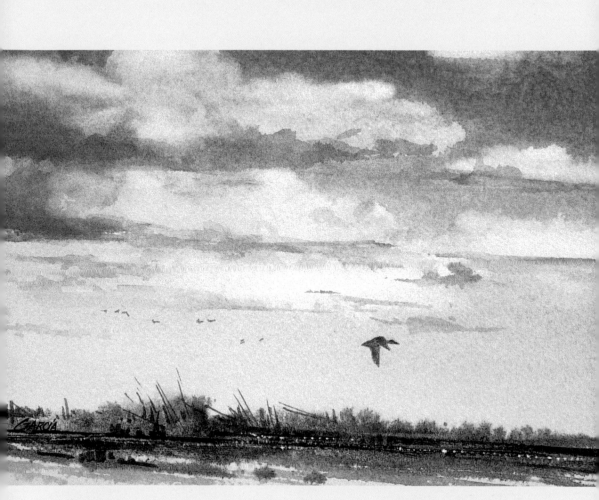

2. Add Details

Continue working on the clouds: scrub, lift color, add shadows, and use hard and soft edges. Watch for value changes as the clouds recede. Finally, glaze a mix of Raw Sienna and Permanent Rose over the clouds. Paint the duck and add a few spots representing distant birds with a mixture of French Ultramarine Blue and Brown Madder. Warm the foreground colors with a light glaze of Burnt Sienna. This helps establish scale and distance.

Fluffy Clouds
Watercolor on 140-lb. (300gsm)
cold-pressed paper
5½" × 8" (14cm × 20cm)

Water Ripples

Think of ripples as small swells or waves on the water. They can have a pattern, rhythm or consistency to their movement, or they can be very broken in flow. Ripples created by wind are less likely to have a pattern than those caused by an object dropped in the water.

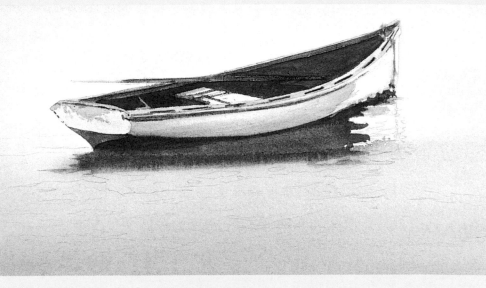

Materials

BRUSHES
¾-inch (19mm) and
 1-inch (25mm) flats
Nos. 2, 4 and 6 rounds

WATERCOLORS
Brown Madder
Burnt Sienna
Cobalt Blue
French Ultramarine Blue
Permanent Rose

1. Paint the Boat

Draw the boat lightly. Paint the hull's bottom and interior with a dark mix of French Ultramarine Blue and Brown Madder. Paint the wood trim with light Burnt Sienna, adding French Ultramarine Blue for the shadow areas. Paint the hull shadow with a mix of French Ultramarine Blue and Alizarin Crimson.

Paint the water with a gradated wet-into-wet wash of Cobalt Blue, French Ultramarine Blue and Permanent Rose, starting the wash with a light value and adding more of the palette mixture as you work down. Let dry. Paint the reflection with French Ultramarine Blue and Brown Madder.

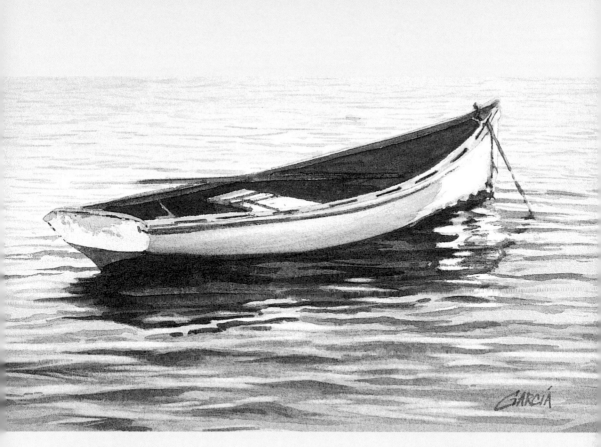

2. Paint the Ripples

Think of each ripple as having a top and sides. Paint the top as the highlight and the sides in shadow. As the ripples move closer, they appear larger and darker. Use a ¾-inch (19mm) flat to lift highlights from some of the larger waves. As the ripples recede, they lose value and detail. In the background, paint the ripples as dashes of value on the wash. Add the anchor chain and its reflection last. The chain's reflection does not show in the highlights of the ripples.

Ripples in the Water
Watercolor on 140-lb. (300gsm)
cold-pressed paper
5" × 9" (13cm × 25cm)

Rushing Water

Rushing water is an opportunity to experiment with creative and spontaneous techniques. The white of the paper represents the flow and splash of the water.

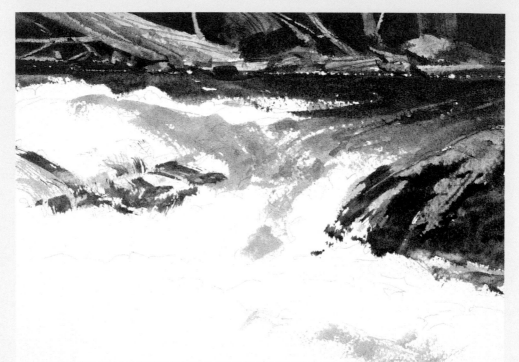

Materials

BRUSHES
¾-inch (19mm) and
 1-inch (25mm) flats
No. 3 round

WATERCOLORS
Cobalt Blue
Brown Madder
French Ultramarine Blue
Raw Sienna
Viridian

1. Draw, Then Paint Rocks and Background
Loosely sketch the landscape and the direction of the water flow. Paint the rocks with Brown Madder and French Ultramarine Blue. Use a palette knife to lift highlights from the damp rocks. Quickly paint the background of rocks and trees. With a mixture of Viridian, Cobalt Blue and Raw Sienna, drybrush texture into the water. Let your strokes follow the direction of the water.

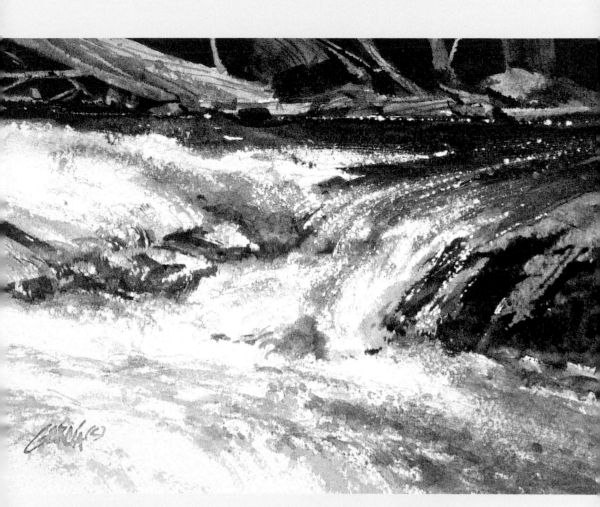

2. Add Final Details
Drybrush the foreground water and add more value around the rocks in the water. Let dry completely. With the flat edge of a utility knife blade or single-edged razor blade, soften the edges of the water by scraping paint away. Use sandpaper to scrape directional flow lines in the water. Be careful not to overdo these textures. With the tip of the blade, scrape highlights into the water's edge in the background and on the wet rocks.

Rushing Water
Watercolor on 140-lb. (300gsm)
cold-pressed paper
5" × 7" (13cm × 18cm)

Old Wooden Fence

Old wooden fences offer a variety of textures to paint in one subject. The textures include peeling paint, rust, dried and cracking wood, and the overall texture of repetitive shapes.

Materials

BRUSHES
¾-inch (19mm) and
 1-inch (25mm) flats
Nos. 3 and 4 rounds

WATERCOLORS
Alizarin Crimson
Brown Madder
Burnt Sienna
Cobalt Blue
French Ultramarine Blue
Olive Green
Raw Sienna

1. Draw, Then Dry-Brush and Add Shadows

Sketch the composition. Paint a transparent drybrushed texture using a thin gray mix of Cobalt Blue, Brown Madder and a touch of Raw Sienna. Drybrush on a little Burnt Sienna for rust stains on the wood. Paint the shadows on the post and pickets to give shape and dimension to the fence, and glaze a light value of Burnt Sienna over the rusty hinge on the fence.

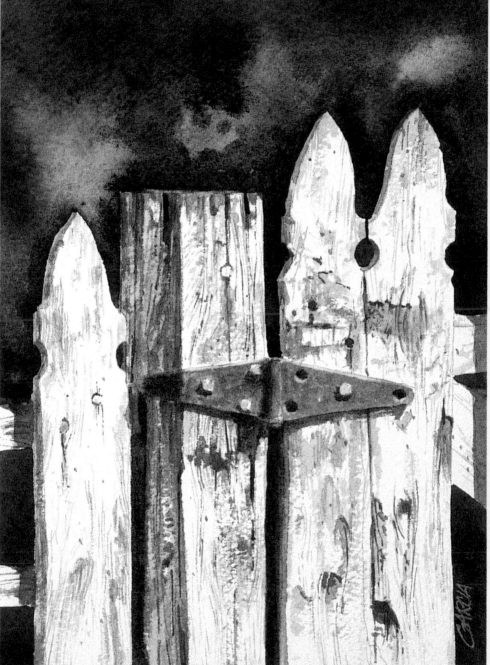

2. Add the Background and Final Textures

Pay close attention to the wood texture on the fence. Paint the holes, cracks and marks using a dark value of French Ultramarine Blue and Alizarin Crimson. Paint the wood grain with a no. 3 round and a light value of French Ultramarine and Brown Madder so the grain isn't too pronounced. When you are satisfied with the texture on the fence, wet the background with water to start a wet-into-wet wash. Paint the background with a rich, dark mixture of French Ultramarine Blue, Alizarin Crimson and Olive Green. Add final texturing on the fence by darkening some of the cracks and splattering the wood with the same light-value color used on the wood grain. Lift color from the empty bolt holes on the hinge to create a little depth.

Old Wooden Fence
Watercolor on 140 lb. (300gsm)
cold-pressed paper
7" × 5" (18cm × 13cm)

Bricks

This painting is of an old brick wall with morning glories growing on it. I passed it on a back street of Sienna, Italy. I used my camera to isolate a few flowers for a painting. This is a good example of using natural and man-made objects together.

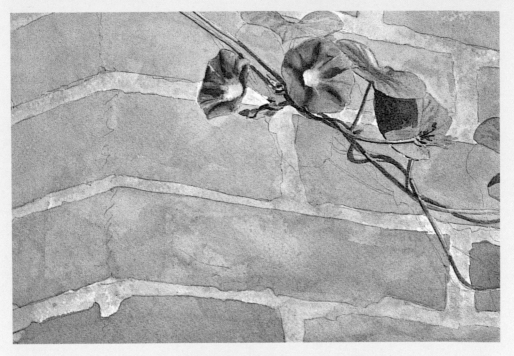

Materials

BRUSHES
¾-inch (19mm) and
 1-inch (25mm) flats
Nos. 2 and 4 rounds

WATERCOLORS
Brown Madder
Burnt Sienna
Cobalt Blue
French Ultramarine Blue
Mauve
Sap Green

1. Draw, Then Paint the Flowers, Vine and Bricks

Loosely draw the bricks, the flowers and the cast shadows. Paint the flowers with a small wet-into-wet wash of Mauve with a little Alizarin Crimson using a no. 4 round. Paint the shadows with a dark-value mix of Mauve and French Ultramarine Blue. Paint the vine and leaves with a flat wash of Sap Green and Cobalt Blue. Use a slightly darker value of this color for the shadows on the leaves and vine. Paint the bricks with a light-value wash of Burnt Sienna, Brown Madder and Cobalt Blue. Try to avoid the mortared areas. You don't want too much dry-brush texture—if the textures or values are overdone, they will compete with the flowers and leaves.

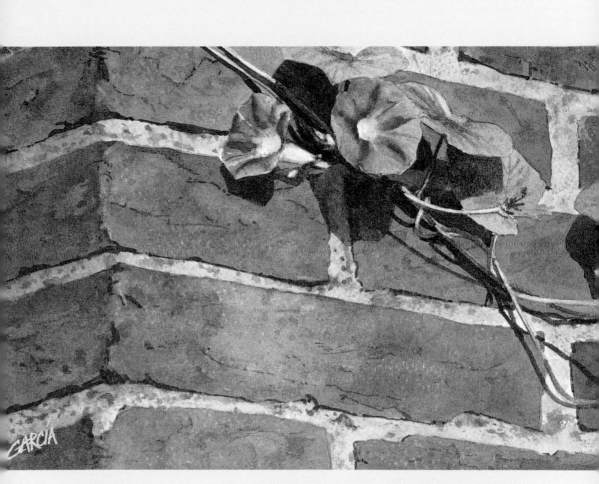

2. Add Final Details

Glaze a mixture of Burnt Sienna and Cobalt Blue on the bricks over the previous glaze. Keep it uneven in value. Let dry. Paint the shadows on the wall, making the area on the left darker to indicate the turning of the corner. Also paint the shadows under the flowers with a rich mixture of Cobalt Blue and Alizarin Crimson. Paint a very light, broken wash of Cobalt Blue and Burnt Sienna over the mortar. Add a dark value along the lower edge of the brick. With a very light value of "palette mud," splatter over the brick area, being careful to avoid the flowers and leaves. Lift color out of the vines to distinguish them from the shadows.

Old or New Brick Texture
Watercolor on 140-lb. (300gsm)
cold-pressed paper
5" × 7½" (13cm × 19cm)

Window Glass

DEMONSTRATION

Glass windows can show reflections or can be dirty, cracked and ready to be replaced. This window was in an old barn. Frosted, cracked and covered with spider webs, the window had seen better days. With a subject like this, take time and care to build up glazes to show the different elements. The broken area is the same color as the cast shadow, just a darker value.

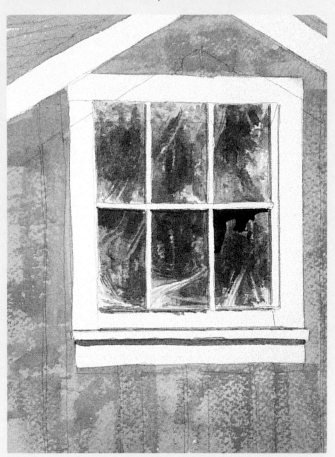

Materials

BRUSHES
¾-inch (19mm) and
1-inch (25mm) flats
Nos. 3 and 4 rounds

WATERCOLORS
Brown Madder
Cobalt Blue
French Ultramarine Blue
Viridian

1. Draw, Then Lay In Base Washes

Draw the composition. Drybrush a mix of French Ultramarine Blue and Viridian in each windowpane with an old no. 3 round. Paint the wall a light-value, loose wash of Brown Madder and just a little Cobalt Blue. Paint the roof with Viridian and use the white of the paper for the trim.

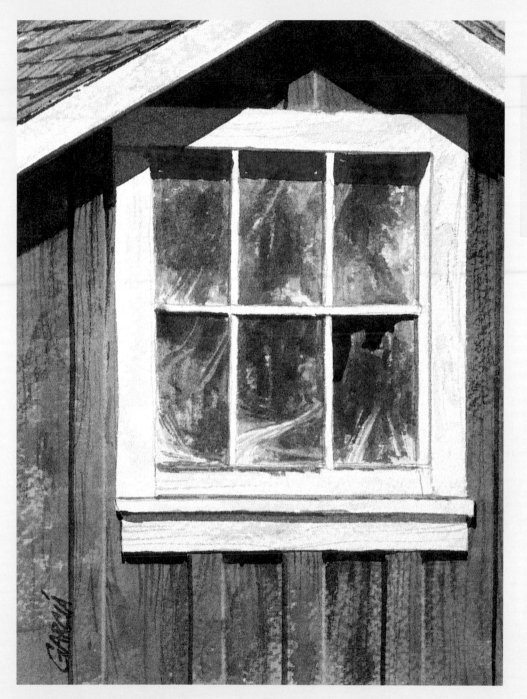

2. Darken the Value on the Siding
Use the same mixture of Brown Madder and Cobalt Blue to drybrush texture and value on the siding. Deepen the value on the roof. Glaze shadows over all the textures, being careful to follow the contour of the siding. Add a very light-value, dry-brushed texture of Cobalt Blue and Brown Madder over the white trim. This adds a little detail and helps the trim not look empty.

Window
Watercolor on 140-lb. (300gsm)
cold-pressed paper
6" × 4½" (15cm × 11cm)

Index

Other fine North Light Books are available from your favorite bookstore, art supply store or online supplier. Visit our website at www.fwmedia.com.

15 14 13 12 5 4 3 2

DISTRIBUTED IN CANADA BY FRASER DIRECT
100 Armstrong Avenue
Georgetown, ON, Canada L7G 5S4
Tel: (905) 877-4411

DISTRIBUTED IN THE U.K. AND EUROPE BY F&W MEDIA INTERNATIONAL, LTD
Brunel House, Forde Close, Newton Abbot, TQ12 4PU, UK
Tel: (+44) 1626 323200, Fax: (+44) 1626 323319
Email: enquiries@fwmedia.com

DISTRIBUTED IN AUSTRALIA BY CAPRICORN LINK
P.O. Box 704, S. Windsor NSW, 2756 Australia
Tel: (02) 4577-3555

Cover Designed by Wendy Dunning
Interior Designed by Brian Roeth
Production coordinated by Mark Griffin

About the Author

Native Californian Joe Garcia lives and works near Julian, California, where the forest of oaks and pines shelter an abundance of birds, deer and other wildlife. It is an area of varied landscapes and a perfect setting for an artist who specializes in painting those subjects.

Joe earned a BFA degree with an advertising/illustration emphasis from the Art Center College of Design in Los Angeles. Since 1983 Joe has painted full-time, leaving the commercial work behind. He published his first book, *Mastering the Watercolor Wash* with North Light Books in 2002.

Metric Conversion Chart

TO CONVERT	TO	MULTIPLY BY
Inches	Centimeters	2.54
Centimeters	Inches	0.4
Feet	Centimeters	30.5
Centimeters	Feet	0.03
Yards	Meters	0.9
Meters	Yards	1.1

Ideas. Instruction. Inspiration.

Receive FREE downloadable bonus materials when you sign up for our free newsletter at artistsnetwork.com/Newsletter_Thanks.

These and other fine North Light products are available at your favorite art & craft retailer, bookstore or online supplier. Visit our websites at artistsnetwork.com and artistsnetwork.tv.

Home | News | Books | Enter Your Art | FAQs | Gallery | Register | About the Editor | Shop

Splash: The Best of Watercolor

The *Splash* series showcases the finest watercolor paintings being created today. A new book in the series is published every other year by North Light Books (an imprint of F+W Media) and features nearly 140 paintings by a wide variety of artists from around the world, each with instructive information about how it was achieved — including inspiration, tips and techniques.

Gallery

Passionate Brushstrokes
Rachel Rubin Wolf

Splash 10 explores "passion" through the work and words of 100 contemporary painters. With each vividly reproduced modern-day masterpiece, insightful firsthand commentary taps into the psyche of the artist to explore where their passion comes ...

Watercolor Discoveries
Rachel Rubin Wolf

Splash 9 holds its own as a visual showcase, representing some of the best work being done in watercolor today. But of course, that's only the half of it. *Splash* is much more than a pretty face. In the same open, giving spirit that ha...

GET YOUR ART IN PRINT!
Go to splashwatercolor.com for up-to-date information on all North Light competitions. Email us at bestofnorthlight@fwmedia.com to be put on our mailing list!

Follow North Light Books for the latest news, free wallpapers, free demos and chances to win FREE BOOKS!